D0107490

EWASO
VILLAGE

Poems and Stories from
Laikipia County, Kenya

By Chip Duncan

SelectBooks
New York

This edition published by SelectBooks, Inc.
For information address SelectBooks, Inc., New York, New York.

First Edition

ISBN 978-1-59079-520-0

Editor: John Sibley Williams

Photography: Chip Duncan
www.ChipDuncan.com

Book design: Kurt Kleman

Library of Congress Cataloging-in-Publication Data

Names: Duncan, Chip, author.
Title: Ewaso village : poems and stories from Laikipia County, Kenya / by
 Chip Duncan.
Description: First edition. | New York, New York : SelectBooks, Inc.,
 [2022] | Summary: "Photojournalist, filmmaker, and author Chip Duncan
 celebrates many years of long visits to Ewaso Village in Laikipia
 County, Kenya. Duncan's combination of images, stories, and original
 poems about the Maasai community reveal his deep admiration for the
 people and their culture"--Provided by publisher.
Identifiers: LCCN 2021051440 (print) | LCCN 2021051441 (ebook) | ISBN
 9781590795200 (paperback) | ISBN 9781590795217 (ebook)
Subjects: LCSH: Duncan, Chip--Travel--Kenya--Ewaso Ngiro. | Maasai (African
 people)--Kenya--Social life and customs. | Ewaso Ngiro
 (Kenya)--Description and travel. | Ewaso Ngiro (Kenya)--Poetry.
Classification: LCC DT434.E93 D (print) | LCC DT434.E93 (ebook) | DDC
 967.62753--dc23/eng/20211019
LC record available at https://lccn.loc.gov/2021051440
LC ebook record available at https://lccn.loc.gov/2021051441

Manufactured in China
10 9 8 7 6 5 4 3 2 1

For Tina,
who opened the door

With special thanks for support and encouragement from Maiyo Lebeneiyo, Kandari Parsulan, Gohar Manzar, Bob Dunn, Ben Santer, Susan Templin, Bob & Kathy Huck, Salim Amin, Jim & Sue Towne, Travis Hamel Olsen, Chris Spheeris, Karen Ellenbecker, Marcia Thomas, Paul Byron, Toby Jones, Theran Pfeiffer, Bill White, Kurt Kleman, Abdul Rahman Ramadhan, Jorge Perez, C.J. Hribal, Michelle Picard, Colin Picard, the Bennett Family, Vicki Malone, Allen Cornelison, Lynne Solomon, Greg LaHaie, Willy Porter, Ambrose Letoluai, Alexandra Crouse, Mike & Pam Buckley, Richard Krzemien, Patricia Foulkrod, Taylor Duncan, Gianni Dusio, Phil Hanson, Daniel Puls, John Dau, H.H. Leonards, Ted Spero, Jason Klagstad, Barb & Frank Durham, John Lavine, Vivien Williams, Ted Midthun, Will Midthun, Gayle Goedde & John French, Willie Karidis, David Barrett, Karen Tredwell, John Henry, Bill Youmans, Christine Saldanha, Jeanette Yoder, Gay Sheffen, Jon Bendis, Barbara Warren, Frank & Susie Kay, Sharon Cook, Betsy Bower, Atsede Ababu, Gebre Ababu, Trupti Shah, Jhaimy Alvarez, Inti Alvarez, Clarissa Estrada, Victor Estrada, Tess Gallun, Paul Cebar, Peter May, Cathy Ryan, Michael Drescher, Brad Pruitt, David Hecht, Patricia & Gerry Ostermick, Adam Ballard, Stephanie & John Ballard, Mike Speaks, Eric Berg, Claudia Haack, Bill Gladstone, Jena Kendall, Bob Kendall, Elisa Casas & Hernando Garzón, Connor and Kendra Benedict.

CONTENTS

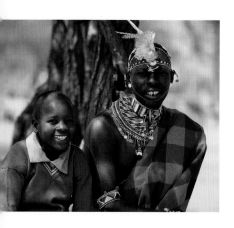

FOREWORD

In early 2008, photojournalist and documentarian Chip Duncan stood side by side with me as we captured the chaos of post-election rioting in Nairobi. It was a tragic time for Kenya. Hundreds were killed during the violent protests. As Chip and I were filming, we were charged by police officers on horseback wielding clubs. Neither of us flinched; we simply dodged their weapons and kept on documenting. It wasn't long before a few fellow reporters and photographers showed up, and the attack against journalists escalated. CNN carried it live as police used tear gas against us in what resulted in a draw. They didn't leave. We didn't leave.

Just two days later, Chip left for Darfur, Sudan to film a medical clinic operating in the midst of rebellion and genocide. At that point, I thought of my father, Mohamed Amin, and his tireless effort to document injustice and to bring the stories of marginalized people to the world. Chip and I were already well acquainted, and that experience sealed a lifelong friendship and professional rapport that is, for me, unparalleled.

I've been covering Africa for the past three decades, and I watched my father do it for two decades before that. Since his death in 1996, our team at Camerapix has researched millions of my father's images featuring East Africa, Pakistan, and Afghanistan. They show the often violent struggle for independence from colonial powers. They feature the injustices and inequities forced upon indigenous people. And they demonstrate how colonial powers methodically stoked the embers of tribalism to divide and rule countries across the continent. The post-election violence in Kenya that Chip and I documented together was a direct result of how the people of Kenya and much of Africa have been left divided following independence. Instead of uniting through governance, tribes and cultures continue to be pitted against one another, communities remain marginalized by poverty, patriarchy, and the seeds of hatred are sown.

Covering conflict, culture, and innocent people scarred by division is a very special skill. It requires humility and a certain amount of courage and focus, but it also requires a lack of judgment and blame. Very, very few can do this in the way that Chip Duncan can. I've had the privilege of travelling with Chip to world capitals to share our stories with policymakers in London, Addis Ababa, Kabul, Los Angeles, New York, and Washington DC. But the places where I've seen Chip thrive and truly excel are in the slums of Kenya's Kibera, the fields of Korem in northern Ethiopia, and the remote mountains of Panjshir and Bamyan provinces in Afghanistan. I've watched firsthand how Chip captures the images and stories of the amazing people he visits in remote parts of the world. I've also seen him capture their hearts.

Perhaps with the exception of my father, Chip operates unlike any other photojournalist that I have worked with. Maybe that's why I feel so close to him. He takes the time to get to know the people he photographs. He talks to them about their lives, their families, and their hopes and dreams. Knowing they are in trusted hands, many open up and share their stories. Many provide access to their traditions and rituals, their personal spaces and possessions, their ideas and their plans. Chip pays this back by telling their stories accurately, without favor and without bias.

Chip also does something I've never seen any other photojournalist do—he returns to the places he photographs as often as he can, and he brings back beautiful prints of the people he's photographed. These gifts are a memory of their time together and a truly unique bond that will last forever.

Photojournalists have a great power to change history and to alter the lives of struggling communities. In a world driven by social media, photojournalists often provide a voice for those in need. Doing it well is a power that must be handled responsibly. When Chip is in the field I have seen how much respect

he has for the people he's photographing and how much he appreciates them for allowing him into their lives. This skill is what makes his images moving, authentic, honest, and powerful.

The book *Ewaso Village* is a celebration of many years of work with the Maasai community in Laikipia County, Kenya. The images, stories, and poems are the result of Chip's numerous visits to the community. He has lived, explored, dined, and danced with them. He's shared their hopes and dreams. And from our hours of conversation about these journeys, I know how much Chip cares about the people and culture he's documented and learned to love. This book provides unique insights into a community that embraces life and the natural world, a place where so many are content and happy despite the many challenges and hardships they face. Long may he tell these stories, long may he capture the smiles of these amazing people, long may his work continue to enlighten and educate the world.

—Salim Amin
 Chairman, Camerapix, Ltd.
 Nairobi, Kenya, 2022

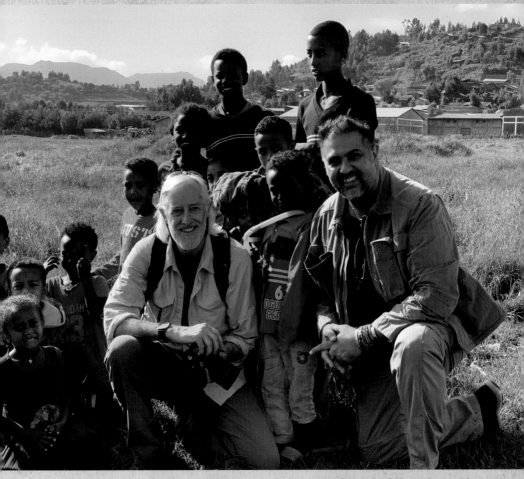

Chip Duncan and Salim Amin on the Korem Plateau in Ethiopia

Author's Note

At the time of this writing, I serve as a trustee for the Loisaba Community Conservation Foundation (a.k.a. LCCF). Five hundred copies of this book have been donated to the foundation to be used for fundraising related to education, student scholarships, food security, and community health in Ewaso Village.

While some of the characters featured in the poems are based on longtime friends such as Kandari, Ambrose, Modesta, and Maiyo, most of the characters and all of the stories featured in the poems are fictional. All photographs were made by the author unless otherwise noted.

In the center of the island, there is Africa.

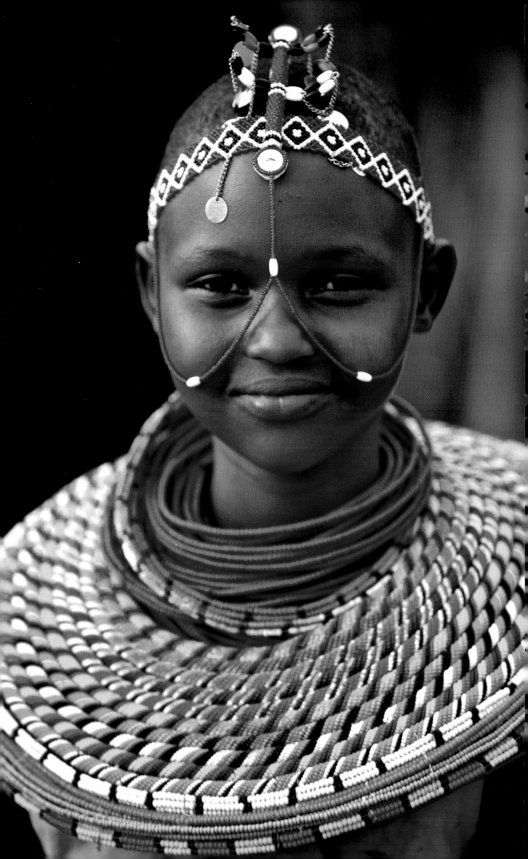

INTRODUCTION

This is a book about birth, death, stars, fire, critters, climate, family, friendship, and keeping bees. The stories take place in the sun-scorched, rolling savannah of Laikipia County and Ewaso Village in rural Kenya. My work as a documentary filmmaker brought me to Ewaso Village for the first time in 2012. As a lifelong resident of America's very green Midwest, little about the brown, parched landscape of Laikipia County spoke to me at first, but the local people did.

As part of my work, I've documented global cultures and spiritual practices on every continent except Antarctica. The Dungchen long horns of Bhutanese monks and hand drums of Haitian Vodou celebrants still ring in my ears. I can still see an Andean shaman tossing coca leaves from atop Peru's Wiñay Wayna, and the sweet taste of dried apricots and raisins puts me right back in Afghanistan's Panjshir Province. But the Maasai people in and around Ewaso Village inspired a part of me that had been buried by deadlines and drive. Their easy laughter and ingenuity now bring me back annually, and their knowledge of the earth has helped me discover new ways to listen, to learn, and to slow down.

During the past few years, I've done numerous speaking engagements that include my photographs of and experiences with the Maasai people of Laikipia County. Some talks include discussion of climate change in sub-Saharan Africa, but most are related to the topic that defines much of my international work for the past two decades. That is, how do we build bridges between cultures instead of building walls? How do we break down stereotypes and build trust? Of course, the simple answer is to get out more, go see the world, and open our minds to the fundamental truth that innovation, creativity, and great ideas transcend borders. The complicating factors involve overcoming our own fear and uncertainty, finding a way to afford the travel and, in my case, putting aside the natural introvert that lives inside me while extending myself through curiosity and a genuine desire to make friends around the globe.

It didn't take many speaking engagements to anticipate a list of common questions about documenting different cultures, including:

Where do you sleep?
What do you eat?
Where do you go to the bathroom?
What happens if you get sick?
Are you ever afraid?

My answers differ depending on the place and climate, but the short answer is that I usually sleep in a tent for about a month each year, I gave up being a vegetarian two decades ago and prefer to eat the food that's local, I go to the bathroom when and where I have to, and when I've been sick, it's usually been intestinal and manageable. Fear is a normal part of life, and it takes many forms. Assessing the risks helps us navigate fear, but at some point a decision has to be made. I can be as uneasy or fearful visiting a Florida country club as I am documenting a Sufi festival in Khartoum or a protest on the streets of Nairobi. But the rewards begin by saying yes. The common denominator I've found documenting cultures around the world is that we are all just people, and the people I meet everywhere I go share a generosity of spirit and desire to make visitors feel comfortable. It's true in a slum, it's true in a palace, and it's true in most places where our intentions are not about taking from or exploiting the people we've come to see. In my experience, the Maasai are the unquestioned champions at making me feel welcome. From my first visit, their curiosity has matched my own, and their kindness to visitors is unsurpassed.

The other question I get with some frequency has to do with my use of the word "privilege." After documenting many natural and unnatural crises including post-earthquake Haiti, Darfur during the genocide, Burma during the last dictatorship, and a few visits to Afghanistan since the 2001 NATO invasion, I've heard myself describe my visits as a "privilege" quite often. It is a privilege because I grow from my experiences with other cultures. With some reflection, I also know that I, like many Western aid workers and photojournalists, sometimes use the word "privilege" to describe our experiences as if to shake off some of the guilt we may feel by simply having the

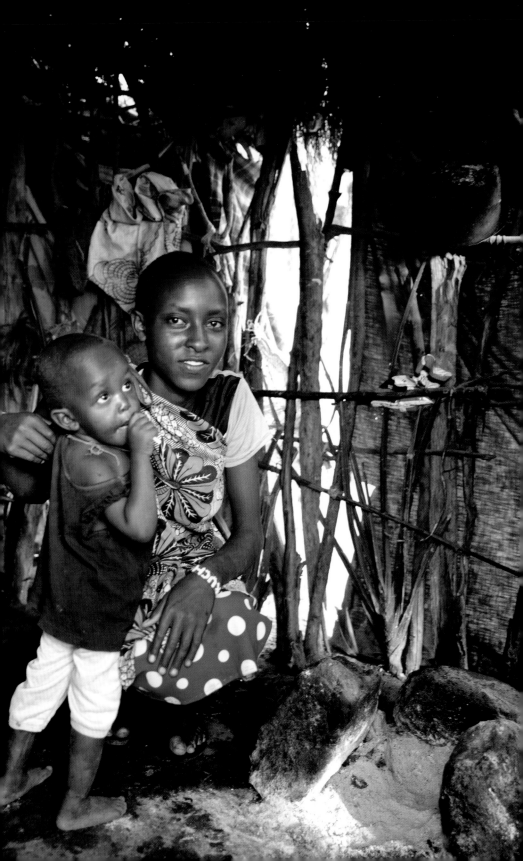

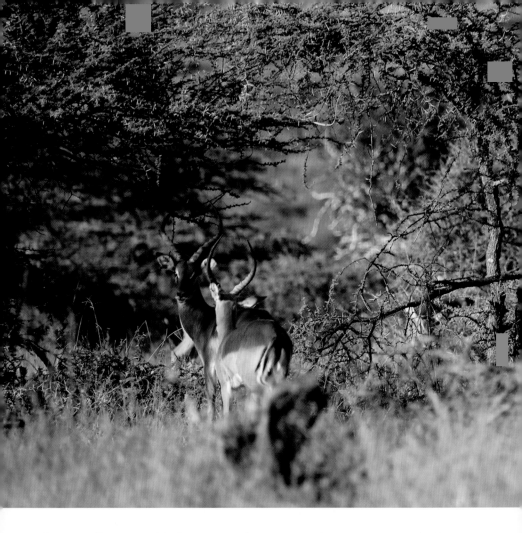

luxury of a reasonable income or the opportunity to get on an airplane and leave at the end of a dangerous assignment. Is it a privilege to do the work? Yes. And it's often a privilege to be able to go home, or even to have a home to go to. The guilt that comes from the privilege of leaving a crisis zone is an age-old part of the journalistic profession and we all deal with it in our own way.

For me, there's another kind of privilege I try to convey in public talks, and it has nothing to do with leaving behind a war zone or natural disaster. In fact, it's the opposite. It has to do with the privilege that comes from gaining someone's trust, honoring their story, and being accepted by people from another culture. That's where Ewaso Village comes in. Is it a privilege to visit my Maasai friends with regularity? Yes. Is it a privilege to sleep in a simple bed

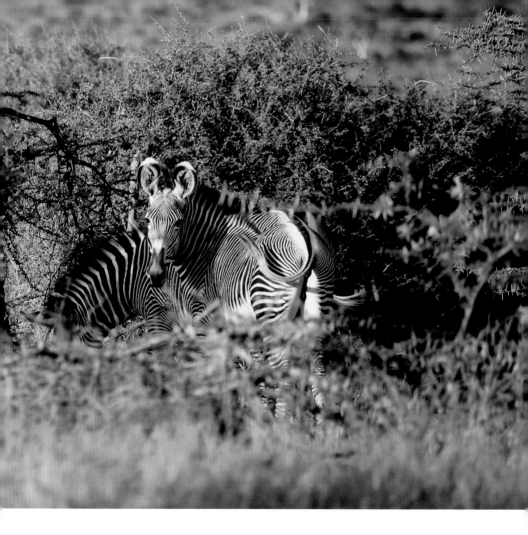

covered by mosquito netting at Paul Lebeneiyo's humble, thatched-roof lodge and to use a cold water shower in the morning? Yes. Is it a privilege to drive bumpy, single-track roads to document a remote schoolhouse or two room medical clinic? Yes. The privilege I experience each time the single-engine plane touches down on the gravel airstrip is their acceptance of a tall, blonde-haired, white guy from Wisconsin and their willingness to include me in their lives. But as close as I've become to this community, I am not a member of it. I'm a friend. When it comes to Maiyo and Kandari, Modesta, Robin, George, and Ambrose, we dive deeply into sharing updates on our families and loved ones, our sorrows, accomplishments, and news of the day, but I will never know what it means to undertake the rite of passage and become a Maasai Warrior. I will never know what it means to grow up as a Maasai woman challenged by male patriarchy, forced circumcision, or abandonment.

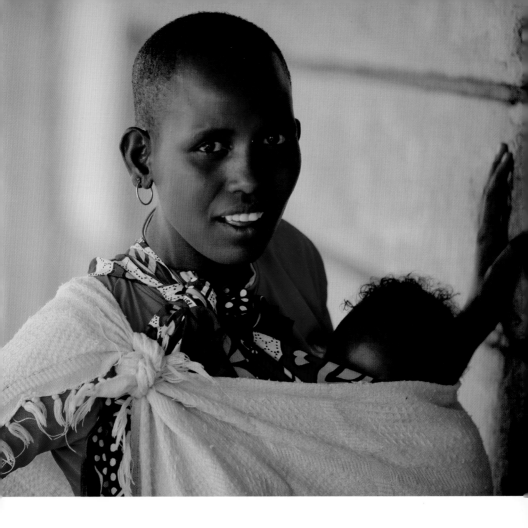

I'll never know what it's like to finish primary school in a cement block building and to take up herding cows, goats, and camels by the time I reach puberty. This book reflects my observations of their community and my desire to share the beauty, drama, joy, and pain reflected in their stories, lifestyles, and beliefs.

The Maasai and their Samburu neighbors are among the few tribes of East Africa that still live off the land, still maintain many of their ancestral values, and in many cases, still honor their nomadic traditions. Among my favorite traits of the Maasai are their love of music and dance, their easy laughter, and their highly evolved sense of whimsy and play. My Maasai friends enjoy being silly, and they love practical jokes, but they're usually based on kindness, not meanness. Like the Andean philosophy of "ayni" that I wrote about in my book *Enough to Go Around*, the Maasai will share their sandwich without

thinking about sharing their sandwich. They are not paying it forward. Sharing is part of being. Having something isn't at the expense of someone else, it's simply having.

As I was building friendships and sharing experiences in and around Ewaso Village, a book of poetry wasn't on my radar. On each visit to the community, I created photo after photo, documented the kids in school, built relationships with teachers, the school cook, the principal, the clinic nurse, safari guides, and jewelry makers. But poetry? Hm.

Then, on a cold spring morning in the Midwest after returning from the savannah, I started asking myself questions about Laikipia County that spurred the more abstract parts of my imagination. What do lions do during a drought? What are the emotional burdens facing ten-year-old girls when forced to dig into the surface of a dry riverbed to find drinking water? What happens to the Maasai when they die? What stars and constellations are in their night sky, and how do they interpret them? What motivates a teacher to keep going when only half the class has a textbook and government support for primary schools is barely enough to pay for chalk? What are the myths of their creation?

The sounds of the bush were also in my head. I could hear the wind passing through leaves, eagles soaring, and elephants tugging at acacia branches. Words started coming—phrases at first—and then, as they began to breathe on their own, I understood that poetry is the way I see the Maasai. They are poetry, an expression of feeling, and a raw, powerful manifestation of the land they call home. Their lives and livelihoods change constantly based on the elemental features of the natural world—heat, water, wind, fire, and wildlife. They share a universal understanding that life will bring difficulty and suffering, and a joyful recognition of harmony when things are going well. When there is drama in Ewaso Village, it's not fabricated by ego or boredom; it's real and unpredictable and often based on dangers that few in the West can comprehend. Their safety net is community—a relative or neighbor will be there during times of need—no questions asked.

The Maasai community I've documented and grown to cherish is about inclusion, and inclusion extends beyond the idea of a nuclear family. I have not met anyone in Laikipia County whose family would fit a Western model; rather, family has an umbrella quality to it. Because many Maasai

are polygamous, no two families are the same, and everyone seems related within a few degrees of separation. Many Maasai families might be more easily defined as communal. It's not unusual to find a nomadic group of four or five huts with twenty to thirty people of all ages living together inside the thorny, makeshift confines of a boma.

The structure of this book, *Ewaso Village*, is a bit unusual. While it's written in English, the poems couldn't have been told without using some Maa— the language of the Maasai. To help provide context, I felt it was important to include some history of Kenya, especially as it relates to land ownership, income disparity, and the allocation of natural resources. I wanted to provide enough background information on the Maasai and on my own work as a documentarian to make the poems enjoyable without forcing a reader to visit a library or hop on the internet. If some part of the facts or history seemed daunting or eye-rolling to me, I cut it. If some truth comes through, it's because the stories come from the Maasai and Samburu people who live in Laikipia County.

Ewaso Village is guided by voices from a community that has given me their trust. We have eaten together, spotted wildlife together, danced and jumped, attended weddings, strung beads, and played ancient instruments by the bonfire. The Maasai have helped me bring words to life and life to words, and to share personal observations about adversity, death, spirit, music, and companionship. With encouragement and the help of many, I've built a career by celebrating the beauty of culture and place, friendship and faith. *Ewaso Village* is my attempt to share the stories of a resilient and colorful community of friends who've built their lives and livelihoods in the shadows of Mt. Kenya.

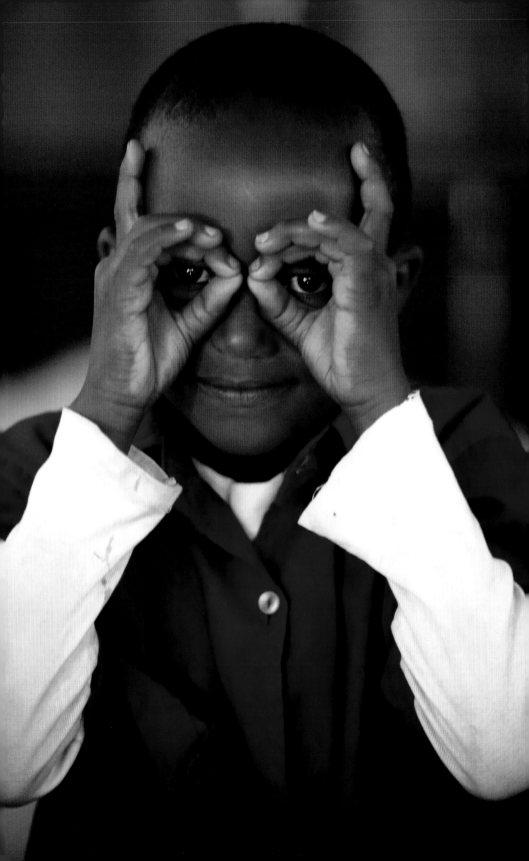

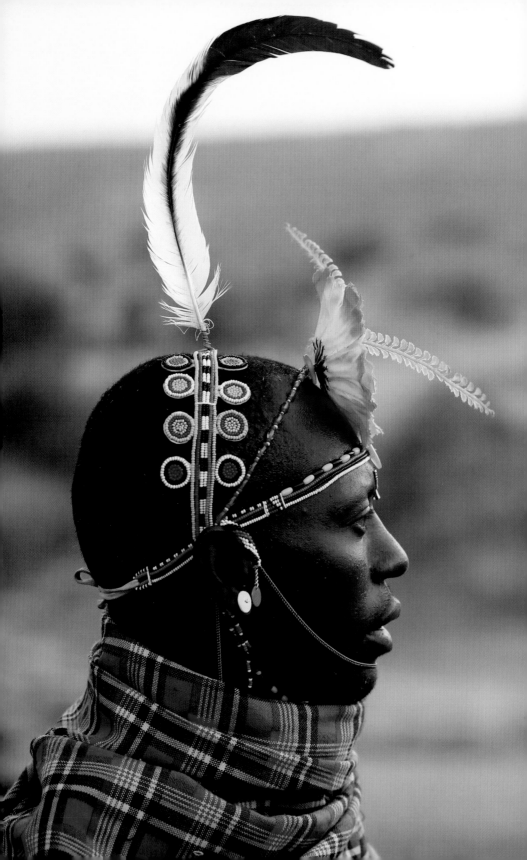

MINGATI, THE NOMAD

Danish writer Karen Blixen, whose work and personal story were popularized in the film *Out of Africa*, wrote a near-perfect description of the Maasai roughly a century ago. Her words remain true to my own experience of the Maasai men and women in Laikipia County:

A Maasai warrior is a fine sight. Those young men have, to the utmost extent, that particular form of intelligence which we call chic; daring and wildly fantastical as they seem, they are still unswervingly true to their own nature, and to an imminent ideal. Their style is not an assumed manner, nor an imitation of a foreign perfection; it has grown from the inside, and is an expression of the race and its history, and their weapons and finery are as much a part of their being as are a stag's antlers.

Like many indigenous cultures around the world, the Maasai history is complicated by colonization along with the industrialization of East Africa. The early Portuguese and later British exploitation of what is now called Kenya epitomizes the dismissive ways in which indigenous communities were treated prior to Kenyan independence in 1963.

The British began colonizing Kenya around the middle of the 19th century. They enforced traditional British laws and customs, conscripted and exploited local indigenous communities for economic purposes, and appropriated vast expanses of land for agriculture and ranching under private British ownership. It wasn't fair, of course, nor legal. The United States government was doing the same thing to American Indians at the time, and around the African continent, the French, Belgians, and Portuguese took advantage of whatever the Brits ignored or left behind. By 1895, the area around the Rift Valley and surrounding highlands became, quite literally, "reserved for whites." Along with members of several other tribal groups from the region, the Maasai and Samburu people never abandoned their homeland, but the lifestyle they'd long cherished was gone.

Of the more than fifty tribes that comprise modern Kenya, the Maasai represent about 2.2% of the total population. Today, they have very little political or economic clout, yet they are expert at maintaining a traditional lifestyle and honoring beliefs and cultural practices that go back centuries, including herding livestock and agricultural systems that are unrivalled in East Africa.

I've witnessed a profound sense of pride and a secure sense of self among the Maasai that seems less common among other cultures I've documented around the world. I may be wrong (my evidence is anecdotal and not based on an anthropologist's thesis), but it appears as if this confidence comes from the deep knowledge and ingenuity required to survive as nomads. For centuries, they have known the land, and their strength of character is reinforced by a desire to maintain a beloved culture and lifestyle despite the accessibility of modern media and government policy. Maintaining their traditions requires faith in wisdom passed down through oral history and a commitment to Maasai values. The Maasai and their Samburu neighbors engage only casually in the politics of Kenya, politics that are still, after almost sixty years of independence, a remnant of colonialism and borders drawn by Europeans. To some extent, the Maasai have adapted to the party in power by ignoring it. Climate change, however, and the demands for energy posed by more than six million inhabitants of Nairobi, present new obstacles, and the peaceful indifference may be changing. For a culture that thrives on communal spirit, there is less and less to go around.

Today, most Maasai live in communities determined by land deals consummated more than a century ago. Not surprisingly, the best Maasai land was either stolen or obtained in questionable deals negotiated by European settlers offering little to nothing to a few representatives of a much larger, voiceless nation. In other words, the Maasai received virtually nothing in return for giving up large tracts of land to British and European ranchers and farmers. It can be argued that the average Maasai family had no idea what was happening to their land, or that a well-financed and well-armed government force was prepared to protect assets they'd essentially stolen. At the time of these transactions, Kenya was under British colonial rule, and there was no legal mechanism for the Maasai to contest the "deals" made by a few elders speaking without permission on behalf of an entire community

Today in Laikipia County, there are power poles stretching across the landscape, helicopters offering scenic flights, and Wi-Fi in the tourist lodges. Some of my Maasai friends work in lodges as gardeners, bartenders, or cooks, and some

guide safaris. Still, when at home, the closest I've seen them come to Western-style conformity is the limited use of cell phones.

Many families in the Laikipia region still tend cows, camels, and goats for their livelihood. Cows are revered in Maasai mythology because they're a central part of the creation story. For the Maasai, cows and people showed up on Earth together and they've been inseparable since. Drought, insects, disease, fire, earthquakes, and the occasional volcanic eruption can change everything except their commitment to cows. Nomadic herder and friend Kandari Parsulan says, "We believe that all cows on Earth belong to the Maasai. They came to us at the time of our creation because we were near to Mt. Kenya, the birthplace of humans and cows." Cultures around the world offer many different creation stories, but having watched Kandari and his family manage their herd of 17 cows, 45 goats, and 3 camels, I take him at his word.

The 21st century has been tougher on the Maasai because drought is now a frequent companion for nomadic herders. Due to dramatic shifts in the climate of sub-Saharan Africa, nothing in their landscape or seasons is predictable. Throughout much of East Africa, the drought cycle has changed from what elders say was thirty years down to what we now know is about three years. During my past three visits to Laikipia County, I've visited Kandari in three different locations. Water is scarce, and getting scarcer. Trees are struggling to survive. Harvests are less predictable. Invasive plant species are threatening as desertification becomes a real challenge, and massive swarms of locusts have become a genuine threat to farmers throughout the region. For Kandari and others, moving the community is part of Maasai life, but unfair treaties and theft of their land in centuries past have created limits on available land. Nomads whose ancestors have lived in the region for millennia often have nowhere to graze their herds, and conflicts over land use can pit conservationists against indigenous groups, neighbor against neighbor, and law enforcement against pastoralists and nomads who, by ethical standards, should have the same land rights as their forefathers. They are, after all, just trying to survive, and they do so by appropriating fewer resources than anyone in the West can imagine. They live practically, use little, and adapt as well as any culture on Earth.

NOTE: The language of the Maasai is called Maa. The Maa name Mingati refers to the masculine gender and translates into English as "the fastest one." Most Maasai in the Ewaso Village area eat only one or two modest meals a day. Breakfast is usually nothing more than a cup of hot, sweet chai.

Mingati, The Nomad

One husband, only one wife.
Four children, three girls
– one old enough to herd –
baby boy, still
need more boys.

Ninety-seven goats.
Sixteen cows.
Three camels.
One queen bee.
Honda Spirit, 2001, two helmets,
one cracked
from rocky fall near Nanyuki.

One hut for sleeping
side-by-side,
six-by-six
sturdy with sticks
and thick
dry grass,
one blue plastic tarp.

One hut for cooking,
five-by-four, more sticks,
more thick dry grass.
Morning chai, two meals a day:
Marrow, blood, lunch.
Goat ribs, beans, more chai, dinner.

Two pots, one pan,
four plates, six teacups.
Just enough wooden spoons
to go around.

Now Mingati, father,
moves herd and family
over and over
for less and less
water
on less and less
land.

LIONS HUNTING WATER

Lewaso Lodge owner Maiyo "Paul" Lebeneiyo is the only local Maasai near Ewaso Village who owns a tourism lodge that conducts safaris. Paul grew up in the village and was educated by Catholic nuns at the local primary school. They gave him his Christian name and, for most outside visitors, he still uses it. Paul has an easy smile, a curious mind, and he's both social and practical. He likes people, and by Western standards, Paul is a genuine entrepreneur. His lodge can go for weeks without guests, but when they do arrive, they're treated like royalty.

A few years ago, Paul hit forty. In the Maasai community, which still has a low life expectancy, Paul is considered a junior elder. People come to Paul for solutions to problems—broken tools, sick livestock, a contaminated well, a poisonous snake in the school house. He's respected. But the changing climate is a problem even Paul can't solve. "We now have strange rain patterns with prolonged periods of drought," he told me on a recent visit. "It's not like before. The lack of rainfall is one thing, but the glacial melt water from Mt. Kenya is disappearing. It's harder and harder to feed our animals. Even rivers and ponds are dried up."

The same environmental challenges impact wildlife. Many things changed following Kenya's independence, but land ownership by white Kenyans and British expats did not. While many of the holdings remain in the hands of third or fourth generation descendants today, some of the large ranches have, over time, become wildlife conservancies. Conservancies near Paul's lodge include both Loisaba and Mpala with more than 100,000 acres of undeveloped wildlife corridor. The conservancies offer unique protection for thousands of species including well-known mammals such as lion, zebra, impala, gazelle, giraffe, dik-dik, hippopotamus, elephants, and the recently rediscovered black leopard.

During the past generation, tourism has grown in the Laikipia area due mainly to wildlife protection and proximity to Mt. Kenya and various national parks. Goodwill policies including conservation have helped local communities mitigate poaching and enforce a hunting-free habitat. But the conservancies have also created unforeseen challenges for nomadic

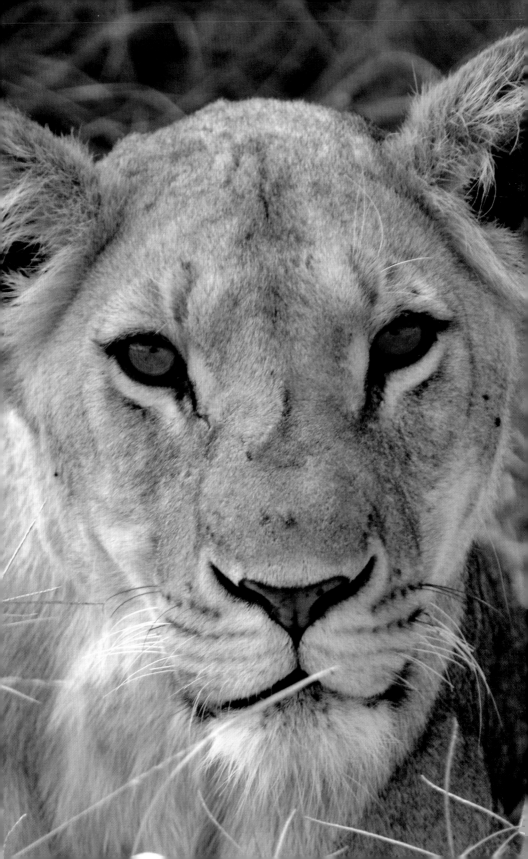

communities that have long used the same vast swaths of land for maintaining herds during drought. Due to a decrease in snow and ice atop Kenya's Mt. Kenya and Mt. Kilimanjaro in nearby Tanzania, dry riverbeds throughout the region have become commonplace. The people and wildlife that call the savannah home must now rely mainly on rainfall to nourish plant and animal life. It's difficult to predict what life here may look like in the 22nd century, but based on current climate trends, the long-term survival of both wildlife and people in Laikipia County is, at best, questionable.

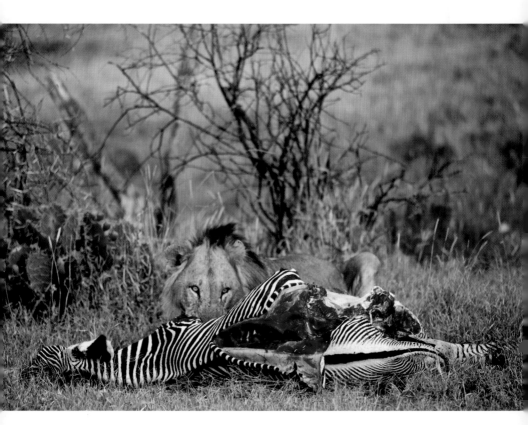

NOTE: A dik-dik is a small antelope that roams the savannahs of East Africa. Adult dik-diks are about the size of a large house cat. They move through the savannah at great speed and, to my eye, their movements appear to be chaotic and guided by uncertainty and fear. They are named after the sound made by a female dik-dik when she is under threat.

Lions Hunting Water

Under dry, faded bush,
three mothers, six young,
a father, confident, loose,
lounging in cool sand
the color of fur.

This never-ending drought
has driven lions east,
their desperate bellies
tortured by thirst,
and paws toughened
by brittle, spikey earth.

But Ewaso River is
dry as bones of dead hyena,
dry as hardened scat
of wildebeest,
dry as cracked feet
of Maasai women
as they slog along
with half-full containers
of silt brown water
from below the river bottom.
Humans have their own struggle,
unaware that lions cannot
dig as deep.

It is easy to sleep in the heat.
And the white chin mother dreams
of muddy paw prints on pond's edge,
of siblings splashing
with wet whiskered faces,
and cool mountain water
dripping from her father's mane.

At dusk, swarms of flies
steal the last moisture from her eyes
until she is awake.
Darkness is the time to move.
Soon, in moonlight,
the pride approaches
the spring of white chin mother dreams,
but even the deepest holes
are filled with fish bones,
gray as sticks, picked clean
by lappet-faced vultures.
Father lion growls
low and slow,
a rumble across the savannah
as if to say, we are all still alive.
And the pride moves on.

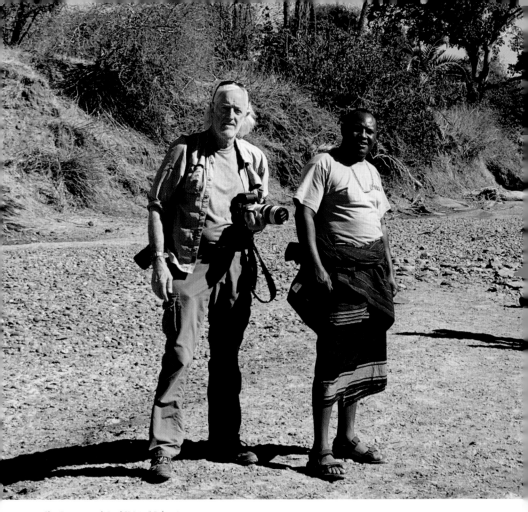

Chip Duncan with Paul "Maiyo" Lebeneiyo

EWASO NGIRO, THE RIVER IS ROAD

The Ewaso Ngiro River runs through both Mpala and Loisaba Conservancies and is within walking distance of Ewaso Village. Its name is derived from local languages and translates into English as "the river of muddy water." Along the parts of the river I've traveled, the banks are four to six feet high and eroded by the chaos of storm water. In the few places where trees border the river, they're atop the banks, often with deep root systems exposed by erosion.

When I first laid eyes on the savannah in this region, it left me feeling naked, almost like I'd lost any privacy I had before arriving. Until I began walking, the brownness seemed monotone and the flatness exhausted itself in the

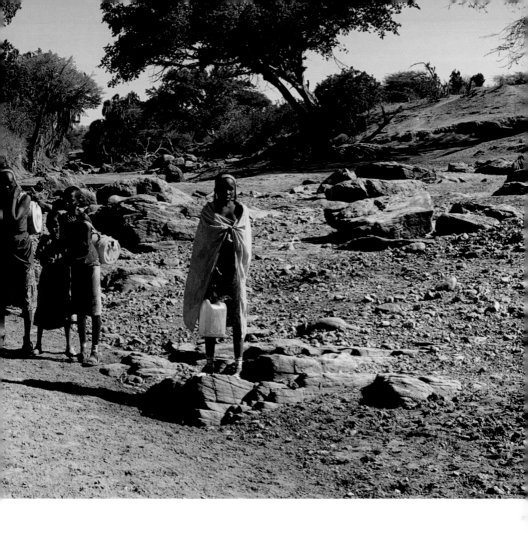

distance, extending beyond my comprehension and the limits of my eyesight. I remember thinking that deserts had always seemed like a blank canvas, a place where my imagination could soar. But the savannah felt unfinished as if the artist quit midway through her creation.

For centuries, the savannah in this region has been nourished by melt water from glaciers atop Tanzania's Mt. Kilimanjaro and Kenya's Mt. Kenya. Though the two mountains are more than three hundred kilometers apart—about the distance from Chicago to Indianapolis—Mt. Kilimanjaro and Mt. Kenya have much in common. Both emerged as volcanoes from an otherwise flat surface in one of the oldest geologic hot spots on Earth, the Rift Valley.

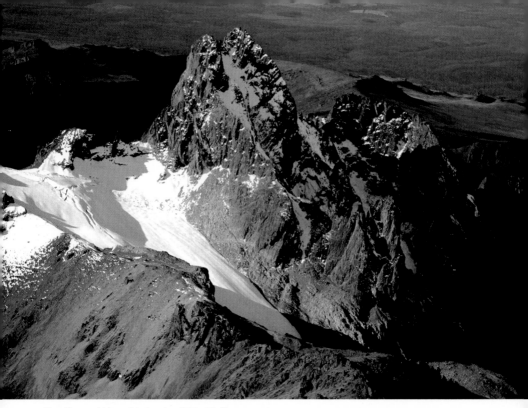

Photo Courtesy: Mohamad Amin – circa 1982 – Mt. Kenya

It's here that many people believe humankind got its start, but that story is for another writer to tell. Each peak rises skyward like a sentry watching over a vast, flat plateau. One peak cannot be seen from the other, and as such, they have little in common with the long ranges of mountain peaks and valleys found in the Andes, Rockies, Alps, or Himalaya. Each peak stands alone. What they do share with mountain ranges is their reputation as a lifeline, a source of water percolating downstream to populations that survive and thrive on their melt water from snow, glaciers, or the precipitation that fills rushing streams and headwaters of great rivers like the Ganges, Colorado, Amazon, and Yangtze. Climate change is occurring in those regions as well, and the impact on humans and wildlife is considerable. For the savannah, the reduced water flow is exposing its fragility. Despite my first impressions, this ecosystem has been an intricate and delicate home and sanctuary for abundant and diverse wildlife for millennia. For the Maasai and Samburu people, the savannah is as important to their survival as Midwest farmlands are

to the American supermarket. Now, the savannah, like much of sub-Saharan Africa, is threatened.

The towering Mt. Kenya is visible from Ewaso Village, but even with a good pair of binoculars, Ewaso Village is not visible from Mt. Kenya. One dominates the landscape, the other barely registers as a village except when driving the two blocks of single-story cement buildings and discarded storage containers that make up the beauty parlor, candy and pop stand, shoe repair store, grain and vegetable storage, and tire and engine repair shops that line the rutted main street. In many ways, however, the villages and family compounds of nomads are as important to Mt. Kenya as the mountain is to their survival. Without the Maasai, there would be no witness to the environmental decline, no voices to offer protest to the developers whose eyes are set on mining, ranching, and wind power, no guides to share wisdom about the nature of nature.

More than just a water supply, Mt. Kenya contributes to Laikipia County as a source of myth, folklore, song, poetry, and adventure. The Kikuyu tribe represents the majority of inhabitants near the base of the mountain. They're also the largest tribe in Kenya representing about 17% of the total population and much of the political power that governs the country. The Kikuyu refer to the giant mountain as Kirinyaga which means "mountain of whiteness." Kirinyaga is the second highest peak in Africa with an icy pinnacle that reaches 17,000 feet in elevation. For as long as oral history in this region can attest, the accumulation of snow and ice atop Kirinyaga has been abundant. Scientific estimates suggest that a thick ice cap has been atop Kirinyaga for thousands of years. Until now. Local climbing guides estimate that of the approximately twenty-six glaciers that existed atop the mountain in 2000, fewer than half remain in 2022. Some estimates suggest that the ice atop Kirinyaga will be gone by mid-century.

Because of the ice melt, many of the tributaries throughout the watershed that once fed the Ewaso Ngiro River have dried up. Rainfall on the savannah has become scarce and unpredictable, and the river that both people and wildlife depend on now runs dry with frequency. During a dozen visits to this community in all seasons of the year, I've seen the river running full only

once. The people of Ewaso Village do not doubt the impact of global warming. It's not a question of belief they say, it's a fact, and they're already learning to live with the consequences.

During an April 2019 visit to Ewaso Village, Maasai elder Paul Lebeneiyo and I toured the dry riverbed in his beat-up Ford Bronco. In an area where water usually collects into a deep pond, we saw three girls digging into the riverbed near the far bank. Each girl had a yellow jerry can to fill. With no hesitation about getting stuck, we drove toward the center of the river on the soft, dry surface of river bottom. "There's only one well near the village," said Paul. "This is where most people come for water for washing, and for their herds. Now the river runs dry for longer than before. It's to the point where we can't count on finding water. A dry well can't be far behind."

For centuries, the Maasai have used the river for water, and when the flow is low or gone due to seasonal drought, they simply dig down into the mud until they find water. On our visit, even the mud was gone. We parked in the middle of the riverbed and walked over to the three girls, all children from the village. The girls were dipping small, hand-held pitchers into a silt-filled hole they'd dug several feet down into the sand. A job that should have taken a few minutes with a running river took hours as they filled their jerry cans a few inches at a time.

NOTE: The word "nyatiti" means "daughter of the clan." The nyatiti is a handmade stringed instrument similar to a lyre that's played in communities across East Africa. The nyatiti usually has five to eight strings. Unlike a guitar or banjo, the strings are not pressed against the neck of the instrument; they're stretched and squeezed to make sound while being plucked, usually by the right hand. Prior to his death in 2019, Kenyan actor and musician Ayub Ogada performed globally while popularizing the nyatiti. Ayub Ogada's haunting original songs were used in numerous film soundtracks including the 2015 short documentary I directed called "The Sound Man."

Ewaso Ngiro, the River Is Road

Once river, now road.
Bald tires spit sand,
silt, sadness.

Herders guide spindly goats
and wobbly calves
with loping parents
along banks of brown, thin
wilted bristle.

Shoulder shore eroded,
and in niches of basalt
and granite, fossils, petroglyphs,
evidence of ages and ages past,
stories as valid as the soft
sand footprints of thirsty grebe,
eland, wildebeest, and gazelle.

Sun eats water.

Sun bakes mountain glaciers
leaving gray rock, gravel, scree.

Sun sucks teardrops
from ancient palms,
their stems shriveled
like gut strings on nyatiti,
their root music crying out
from crusty calloused
hands of warriors,
survivors.

Village boy of twelve
stands in river bottom
digging, digging until
his bare brown feet feel
the life force.

Village girls, old enough
to carry a family's burden,
lower buckets into round holes,
scooping sediment
from the last inches
of Mother Earth's
muddy water.

Later, after beans and nuts
and cleaning teeth with
tiny sharpened sticks,
there is time for tea
in the square hut,
a family together,
with just enough
for now.

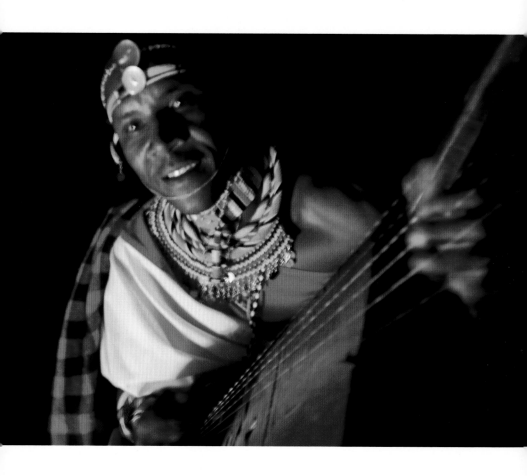

NOTE: The Maa name Naeku translates into English as "born in the dawn." Paul's birth name in Maa is Maiyo. Kingasunye is a common Maa name that means "chubby or fat." Nataana translates as "born of a neighbor." Boma is the word the Maasai use for "stockade or enclosure." It can also mean "camp or small fortress." For many nomadic communities, both livestock and people sleep inside the confines of the boma. Mt. Kenya, the highest peak in Kenya, is often referred to by its Kikuyu name, "Kirinyaga." Like Mt. Olympus to the Greeks, Mt. Kenya is the birthplace of humanity, the sacred source where life began. A part of folklore in several parts of Africa, a Nandi Bear is similar to the Abominable Snowman or Yeti. Nanyuki is the largest town in the Laikipia County region with a population of about 50,000 and two hospitals.

NAEKU, BORN IN THE DAWN

The average Kenyan has never heard of Ewaso Village. Most never will. But Ewaso Village matters in the same way that all villages matter, they are often places where basic needs are met through family, friends, and neighbors. Most of the people in Ewaso Village know each other, and few rarely venture further than the city of Nanyuki some eighty kilometers away. Some never leave at all.

A black metal gate and hand-painted sign identify the primary school on the eastern edge of town. The ramshackle fencing around the school isn't to keep the kids in; it's to keep wildlife out. Just fifty feet from the school entrance, there's a cement block, two-room medical clinic staffed by a visiting nurse. The nearest hospital is in Nanyuki. Any health care at all is a luxury in these parts, and the lack of qualified assistance begs the question: What happens when the baby decides to come in the middle of the night?

Lewaso Lodge owner Paul Lebeneiyo is one of the few Maasai elders in the village who owns a vehicle, and he drives the bumpy dirt road at least once each week to pick up supplies from Nanyuki. When Paul bought his first 4x4, he expected neighbors to ask for help with hauling crops or textiles to market, or to hitch a ride to the bus station. What Paul didn't anticipate—and what still mystifies him—is that being called upon to transport the sick, the elderly, and the pregnant to Nanyuki's hospital would become routine. Paul has no training as an EMT or medical assistant, but he's become one nonetheless. "Babies come when they come," says Paul. "I've had at least a dozen women give birth in the backseat of my Bronco."

That's a dozen and counting. Since Paul told me about his makeshift delivery service in 2018, two more women have come to him in the middle of the night in search of help getting to a midwife or hospital. According to Paul, the most important skill he's learned is to keep mothers calm and safe while bouncing down a dangerous dirt road en route to a secure place to deliver a baby. As I write this, Paul's Bronco needs new tires and shocks. The engine overheats, especially during afternoon heat. The seats are faded from constant wear, tear, and cleaning. During a health crisis in 2019 that saw the unexpected death of nine villagers from contaminated water, Paul transported more than seventy-five people round trip at a distance of more than 10,000 total kilometers. "It's not ideal," says Paul, "and at times it's heartbreaking. But we do the best with what we have."

Naeku, Born in the Dawn

Part One – The Water Breaks

Nataana dreams the rains come,
gullies fill with water,
fish thrive, ducks school and dive,
and elephants spray their bodies
like a cool shower, snout after snout.
But it's just a dream.

Natanna feels her bottom,
and a wet patch on the old blanket.
The nest between her legs is slippery.
Natanna brings fingers to nose
… nothing.
What is it? she wonders,
still hoping the rains are real.

Beside her in the darkness,
 Gabriel stirs.
The goat blood from dinner
is dry on his lips
like a kiss full of tasty promise.
It will be gone by morning.

Gabriel dreams deep:
he's a boy again,
hunting lions to prove himself,
a boy with grandfather's spear
pleasing a father with his kill.

Nataana sneaks from their bed
with the light touch reserved
for holding a newborn, a careful hand
on her round belly.
Even at fifteen, her inner voice knows
what stars and spirits know,
a new life is waiting.
But there is no training for this,
no more than the kiss.

Natanna moves like she's fearless,
inspired by the urgent pulse
of a soul inside her
searching for light, breath.

Outside, in darkness,
an Eagle Owl dives
from its acacia perch,
s c r e e c h i n g,
its whirl of wings
warning Kingasunye, a sister
who is like a sentry, ready.
Time has come.

There was no midwife for Kingasunye.
At fourteen, she learned from the death
of her first, a miscarriage in a tender womb,
and at sixteen, from a baby born
on blood red ground
near the boma gate.
Two worlds converged that night –
baby uncertain, crying,
mother uncertain, crying,
with nothing to go on but instinct.
Now it is Natanna's time
and she will have the hand of a sister.

Kingasunye tiptoes into the night
and with sister love
she takes Natanna's hand
to comfort and share in this cycle of life
as Natanna's story becomes
as real as her own.
Did they talk this through?
Kingasunye wonders.
Does Natanna understand?

Naeku, Born in the Dawn

Part Two — Journey & Birth

A fat moon casts shadows
on the bush, and hand-in-hand
Kingasunye guides Natanna
to Maiyo's hut.

The baby inside drops
inch by inch as they move
through the bush,
and Nataana cramps
with mama pain, cramps
with fear and guilt
as her own mother's voice
plays in her head:
"There are lions beyond the acacia fence,
 lions that wait to eat children
 in the darkness."

Nataana squeezes Kingasunye's hand,
their sweat pools in palms
as two women
bound by marriage to two brothers,
two brothers who seed children,
two brothers sleeping now,
ignorant, unwilling.
They are two women
bound by spirit
of an ancient earth mother
and the sacred source of Kirinyaga,
mountain, birthplace.
Natanna and Kingasunye lock fingers
in moonlight, their bare feet
steady and sturdy
in the bush sand.

Near the village,
Maiyo sleeps like a Nandi bear,
strong beyond strong,
his deep breaths audible
behind the clay walls of his hut.
Maiyo is wise, thinks Kingasunye,
Maiyo is kind. Maiyo is good.

With a prayer inside her,
Kingasunye tosses pebbles lightly
on the tin rooftop of Maiyo's hut.
With no reaction, she tosses handfuls,
and the sprinkle of dancing stone
is louder than monsoon rain.
Nataana, cramped with fear
of night, lion, mother, baby,
jumps when Maiyo growls
himself awake.

Soon enough, they are three together
in the dented Bronco bouncing
through ruts and holes,
its four wheels swerving on soft gravel,
dodging dik-dik, springhare, civet and fox
intent on slowing their journey.

An hour into the drive,
a drizzle of pink morning light
hangs like dust above the savannah.
Maiyo knows these things –
this has happened before –
and he brings their bodies
to rest on roadside.
Kingasunye sees the belly drop.
Nataana, afraid to scream her pain,
leaks blood
and baby body
on back seat.

Her dimpled head seeking light,
Naeku leaves the womb,
a new child with child mother.
Born in the dawn,
Naeku is innocent, aware, alive,
as Maiyo and Kingasunye smile.

In the back seat, Natanna,
new to this, yet ready in her own way,
holds baby on mama belly,
bathing her with tears of love.

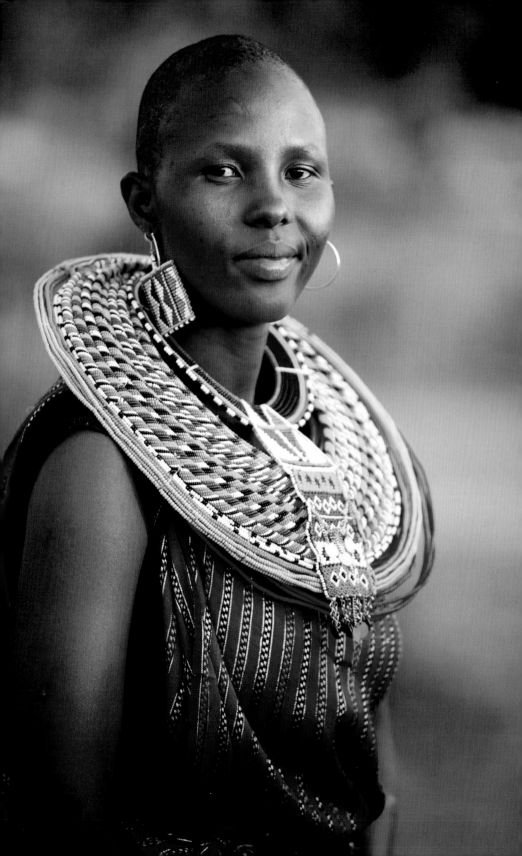

CHUI MAMAS

During spring of 2004, I made the first of three visits to Afghanistan as a filmmaker. The war was in full swing, but most of my journey was in relatively peaceful regions around Mazar-el-Sharif. I was able to document many remarkable things with my cameras, but none more powerful than the opening of a new primary school about eighty kilometers north of Kabul. When I left our hotel, I expected little more than tea and handshakes. But after four decades of photojournalism and documentary filmmaking, that celebration remains the most important event I've ever covered.

The opening of the school was an occasion for both children and dignitaries to celebrate a new era in public school education. The recently painted school building was decked out with balloons and colorful paper cutouts hanging from string. A parade of children wearing their best outfits greeted each small delegation, and smiling teachers extended their hands with warm invitation. The classrooms were open for visitors to see their desks (some new, some old), chalkboards with salutations written in various colors of chalk, and an assortment of newly printed books including many with English titles. A temporary event space had been created in front of the building featuring a rickety old lectern and folding chairs set precariously atop five or six beautiful Afghan carpets. But what made the event so profound by Western standards was simple: girls of all ages were going to school for the first time.

For most of the 20th century, Afghanistan struggled with challenges defined by its status as a landlocked nation along with challenges related to literacy, poor health care, ethnic strife, religious intolerance, a lack of roads, and a physical landscape of mountains and valleys that made it difficult to conduct trade. But it was the Taliban who forced women back into the dark ages. The very dark ages. During the roughly two decades prior to the 2001 NATO invasion, the phrase "women's rights" was an oxymoron. In fact, women had no rights at all. Simply put, women were the property of men, and girls were not allowed to go to school.

During our visit to a tiny schoolhouse north of Kabul, male VIP after male VIP took the podium, and then during rambling speeches about "change" and "progress," each took credit for their new "experiment" in educating girls. The event would have felt predictable, hollow and unrewarding, except for the

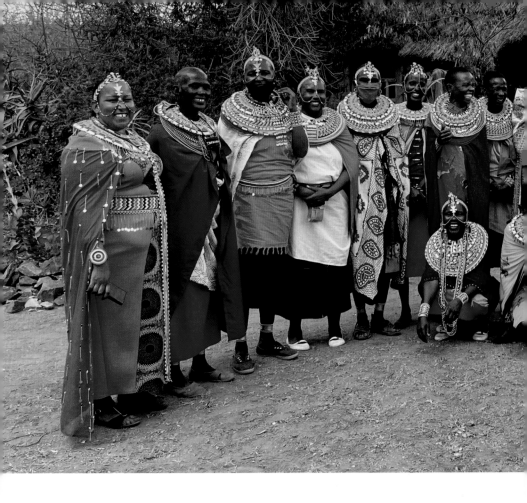

final speaker. A girl of about twelve was allowed to take the lectern.
Two kind men put a stool under her feet so she could reach the microphone.
I don't speak Dari or Pashto, the primary languages of modern Afghanistan,
so my own emotional response to the girl's address was based on the singular
idea that a group of men, men educated in a strict form of Islam that
deprived women and girls of a life of dignity and equality, had just stepped
aside to let a young girl speak to a crowd of dignitaries. The opportunity
for a girl to speak was, at the time, unheard of, and it represented societal
change that no one could have predicted prior to the NATO invasion a few
years earlier.

At the time of this writing, the Taliban have, once again, taken control of
Afghanistan. During a chaotic evacuation that captured global attention,
NATO and U.S. forces have departed Afghanistan. The vast majority of U.S.

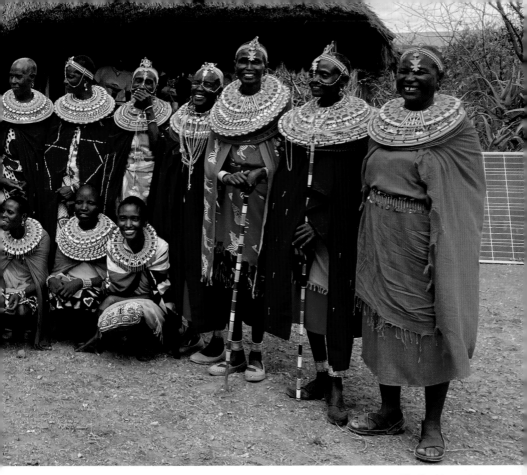

The Chui Mamas – 2021

citizens have also departed including many who worked as teachers or for global not-for-profit organizations. The future of women's rights hangs in the balance. Though Taliban leadership has promised that girls and women will continue living freely, early indications are that girls will be separated from boys in primary schools with little to no opportunity for higher education.

As one who's traveled widely to developing nations and crisis zones, hope for a brighter future, a stronger economy, and a reduction of conflict and violence often hinges on the rights of full expression, education, and equal opportunity for women and girls. Kenya has come a long way in recognizing women's rights, including the most important right in any democracy, the right to vote. For most of the 20th century, girls in rural Kenya had equal access to education, but access didn't translate into practice. Catholic nuns taught at the few schools in Laikipia County, including Ewaso Primary. As if bowing

to the patriarchy that continues to define the Catholic Church, the nuns in Ewaso Village did little to empower, inspire, or encourage women and girls. As part of their push to Christianize Kenya's rural population, the nuns discouraged their Maasai students from using their native language, including replacing Maasai and Samburu names with Christian names. Maiyo became Paul. Kandari became Boniface. Naisiae became Elizabeth. Naserian became Mary. The idea that God might better recognize local kids by using names with a Latin root is certainly far-fetched, but the church did it nonetheless.

Today, the roughly 800,000 Maasai people in East Africa are reclaiming many of their traditions, and some young Maasai now speak the Maa language as well as Swahili and English. Many recognize and use both their Christian and indigenous names. The challenges facing Maasai women remain considerable, with high birth rates, a short life expectancy, and high infant mortality rates. Most of the adult women I know in the Ewaso Village area can't read, and few have access to meaningful employment. In a polygamous culture, their lives are often complicated by abandonment from husbands who leave behind wives and children while simply moving in with one of their "other" wives.

Under a law passed early in the 21st century, primary school is now free for all citizens of Kenya. Yet fewer than fifty percent of Maasai girls attend primary school and only about ten percent go on to secondary school. Instead of empowerment and freedom, many Maasai girls are subjugated by forced circumcision during early adolescence, and many are married off to a man chosen by the girl's parents. Some girls are traded into marriage in exchange for livestock or money, usually well before their fourteenth birthday. Girls who receive an education are vastly more prepared to make their own choices and often have a greater voice in creating their own family and destiny. Several not-for-profit organizations work in the Laikipia County area to provide opportunities for girls as well as scholarship opportunities for both secondary and college education.

Throughout Laikipia County, many older women live without financial support, opportunity, encouragement, companionship, and the love of a partner. Very few have internet access, transportation, or health care, most have no bank

account or savings, and most have never been taught how to manage money. But things are changing, especially as more parents send their daughters to primary school.

Hope begins in many ways, and in Ewaso Village, women educating women, women protecting women, and women empowering each other are now everyday features of this evolving community. Since 2018, the women of Ewaso Village have found comfort by sharing their stories and by becoming entrepreneurs driven to build their own future. The *Chui Mamas*, which means "Leopard Women" in English, is the name of a new collective that comes together regularly in a small outdoor setting to create traditional Maasai jewelry, bowls, and clothing for international markets and tourists visiting Kenya. In a move toward local sustainability, the Chui Mamas started their own bakery in 2019 and now serve villages throughout their county. The work of the Chui Mamas is now exported globally, and their profits are shared among all of the participating women.

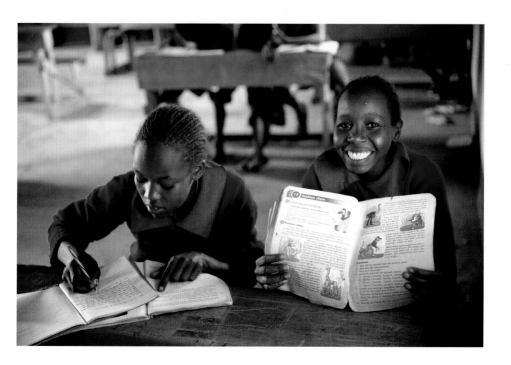

Chui Mamas

Preparation

Midday is coming, the time
when leopard women assemble
under soft-edged shadows
of giant acacia tree.

Elizabeth prepares for gathering,
sweeping dry leaves from dry earth,
her legs taut and body bent
with full hips low to the ground.
Stiff bristles of broom
work like a paintbrush in sand
as she sweeps circle after circle
of swirling lines.
When this tired woman stops
to ponder the patterns,
she has made the heavens,
each wilted berry a damaged planet,
each torn leaf a comet,
each pebble a lifeless asteroid,
each grain of sand a star
that will sweep itself through darkness
leaving a trail of light
across a night sky.

Arrival

Mary and Modesta
have dreamt of this tree
as if it is the lone survivor,
the last safe shelter.
It has saved them, time and again,
from the heat that never leaves.
This piece of heaven beneath it
is their respite, their hope,
the place where words are heard,
smiles come easy,
and tears replace fears.

These legs have walked miles.
These arms have lifted babies.
This back has carried wood
 and water.
These ears have heard cries
 from sickness.
These eyes have seen sadness.
But for Mary and Modesta,
this breath and the next, are life.
Using hands for balance,
they wince and sit until
earth becomes chair,
and bodies imprint heaven.

Mary unravels a mama goat hide,
its leather limp and loose from use
as a table without legs,
a thin surface for collecting tools:
beads, thread, needles, jars,
reading glasses with a single stem,
and fat salve for calloused,
 split fingers.

Modesta unties the cloth pouch
she has carried since childhood,
an heirloom from Jael, sister
who died with child in belly.
Like sibling memories,
the pouch is faded,
smudged with charcoal,
dirt from the cook room floor.
She removes her worries
and three bottles of beads,
setting them like sentries
within reach of each
Chui Mama.

Others arrive – Deborah, Abigail,
Eunice, Ruth – each with stories
of their own, each inviting
the spirit of leopard women,
strong, smart, steady,
ready to be heard.

With each sip of chai, a new story:
Daughters in secondary school.
Sisters studying with brothers.
A principal named Sarah.
The rumor of a wedding
where the girl had a choice.

Work

Many hands speak
active with art and spirit,
active with ancestral colors,
patterns and prayers.
Chui Mamas giggle
as they wiggle tiny beads
on string and metal for market.
Elizabeth smiles. For now,
this is heaven.

DIK-DIK

Lions are reclusive, surly, often lazy, and difficult to spot unless they're eating a rangy gazelle or the bloody torso of a dead zebra. Hippos are dangerous to rafters, and often deadly, but when they surface in rain-filled ponds near Ewaso Village they're little more than a head above water like a bobbing black soccer ball. Leopards are mostly nocturnal, elusive, cagey, and rarely seen unless they're basking fat and full on a tree limb at dawn. Like giant boulders standing alone on the vast savannah, rhinos are among the most endangered species on Earth. Ivory poachers with greedy souls have pushed them to the brink of extinction with illegal hunting and sure death, even in national parks.

The word "safari" means hunting or observing animals in their natural habitat. It's still possible to hunt legally in some parts of Africa, but in Kenya, safari means "observing" not hunting. There are no gun barrels on safaris in Kenya, just long lenses capturing images of wildlife going about their day. Proceeds from safaris in Kenya help create sustainable livelihoods for rural Kenyans and provide protection for animals that share the land.

My first Laikipia safari experience was unintentional. After landing on a gravel airstrip that defined the phrase "middle of nowhere," I was greeted by three Maasai Warriors wearing their traditional clothing and jewelry. Robin, who speaks no English, tossed my bags in the rear of his Land Cruiser. His companions hopped into a second open air 4x4 and off we went en route to Paul Lebeneyio's quaint Lewaso Lodge. While it may seem obvious, it hadn't occurred to me that the wildlife I'd come to see would just be ranging around the bush as we drove through it on a single-track dirt road. It was midday, the light was terrible for photography, and the savannah was dry and brown from prolonged drought. With the sun almost directly overhead, there were no shadows in the bush. For a photographer, flat light usually means keeping cameras in their cases.

"What the heck am I doing here?" I asked. Robin smiled but didn't respond. "This bush stuff is truly bleak. Where are the rolling grasslands? The jagged, snow-capped peaks? The roaring river? The red rocks waiting to be climbed?" With humility and pride, Robin drove on. I was a visitor to his home, and nothing was going to rock his world, especially not a cynical tone of voice in a language he couldn't comprehend. Instead, Robin pointed out a fast-moving ostrich. A few hundred feet further along, he handed me binoculars for a look at a herd of elephants on a distant hillside. He made sure I was aware of the

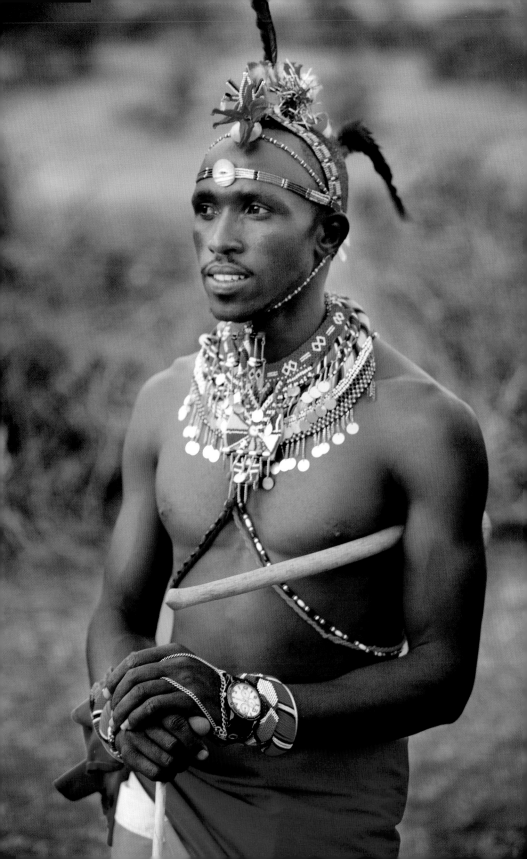

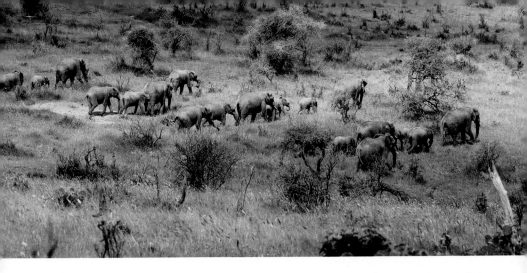

fish eagle flying overhead. It wasn't long before I realized that Robin didn't need words to let me know he was glad I'd come to Laikipia County, and he was excited to show me his home. Each time he pointed out new wildlife, his smile urged me to embrace the strange landscape we were traversing. Maybe, I thought, I'm here for the wildlife and the people.

As we drove through a section of low bush and invasive prickly pear cactus, I sensed something moving. My eye wasn't trained yet for the bush, so I couldn't actually see a thing, it was more of a feeling of movement. There it was again, but this time a strange creature caught my eye at ground level near the brittle roots of dying brush. That's when Robin pointed and said,

"Dik-dik."

"A what?"

"Dik-dik."

And before I could spot it again, the dik-dik was gone.

It didn't matter that Robin handed me the binoculars again for a closer look, because dik-dik move faster than my calculus and my coordination. About the size of a newborn fawn from a white tail deer, dik-dik move with rare agility guided by a brain only a fellow dik-dik is likely to understand. They're way too fast to pin down with a couple of monocles attached to a center point. From the antelope family, a dik-dik looks like a brown, jerky fox terrier with the bold, unpredictable moves of a fussy Irish sheepdog. Even at high noon in desert heat, they're out and about, scurrying with what I assume is fear of premature death. A dik-dik is definitely food for a hungry African cat, or maybe even an eagle, but first they must be caught.

Dik-Dik

Fear
lust
anxiety
confusion
aggression.
These alone
do not explain
the dik-dik.

Wind
heat
thirst
desire
and hunger
also force the rapid feet,
lunges and ludicrous leaps
and brisk, blind turns,
beyond belief.

Hyenas laugh.
Ostriches trot.
Eagles screech.
Snakes slither.
Giraffes
swoop
and
swerve,
and lions snooze
in the crisp
crusty bush,
wondering,
"what's your hurry?"

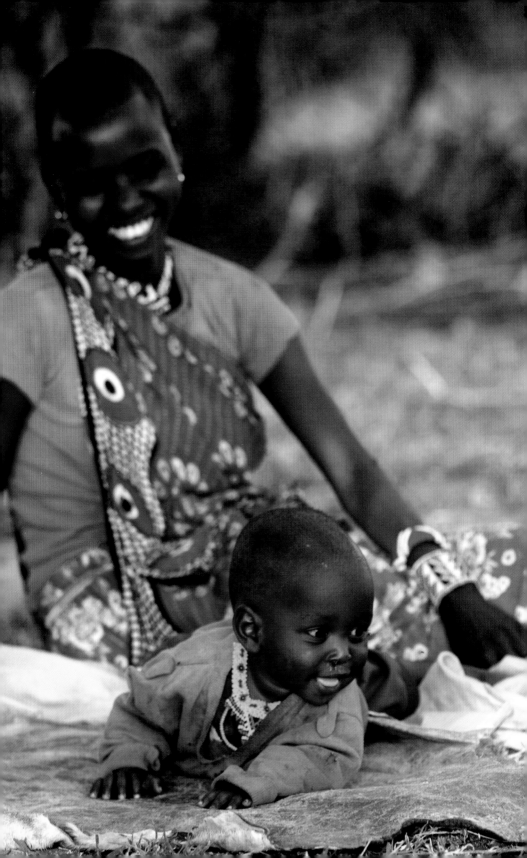

LEBOO, BORN IN THE BUSH

While visiting Port-au-Prince, Haiti, to document Vodou rituals during a mid-90s film assignment, my colleagues and I shot for several hours in the infamous Grand Cemetery. Like most tropical cemeteries, it was overcrowded, its whitewashed vaults were crumbling, the headstone engravings were faded and mostly unreadable, and the humid, putrid air telegraphed its destructive power like a slow-motion wave eroding a useless beachhead. Unlike most cemeteries, however, the Grand was also home to hundreds of homeless Haitians, many of whom slept directly atop the flat crypts. The amalgam of life and death bombarded our senses. We witnessed the funeral of an elderly woman whose body was being placed in a tomb by two grief-stricken sons and watched a procession of mourners as a trumpet player blasted disturbing, flat notes that echoed through the catacombs. Priests chanted in Latin as limp candles dripped hot wax on their calloused hands. But nothing before or since was quite as heartbreaking for me as the abandoned child we encountered on our exit from the cemetery. A crying baby no more than a few days old was wrapped in a thin pink blanket and had been set on uneven sidewalk slabs directly in the midst of anyone walking by. Who abandons their newborn child? I wondered. The question haunts me to this day. When a new mother is forced to lay her child down on a busy sidewalk with the hope of rescue by a person better equipped for caretaking, the sense of desperation she feels must be incomprehensible. Was it a lack of food, water, or shelter that inspired her actions? An abusive spouse? Unemployment? An unwanted pregnancy? Too many mouths to feed already? Any of us can judge the mother's actions, and many do, but I imagined that her agony was real, and over time, the haunting, ongoing question for me was what happened to the child? Who learned to love and nurture that child? What were the child's chances for happiness, or to live a meaningful life?

Twenty years passed before the memory of that child found its way into a poem. Little about Ewaso Village reminds me of Port-au-Prince. They are, literally, a world apart. But a child is still a child, and the future of any abandoned child is determined by so much more than the challenges facing a distraught parent. It's certainly true in Ewaso Village where every newborn—including those who have been abandoned at birth—face challenges unlike those in the West.

Free primary school education in Kenya is a relatively new concept. I would argue that it's one of the things that separates Kenya from its East African neighbors. Free primary school represents a commitment to literacy, and a commitment to hope and promise, and it's a government sponsored human right. Despite previous post-independence efforts to provide quality education for all young Kenyans, it wasn't until 2003 that the government of then-President Mwai Kibaki introduced free and compulsory primary school education.

Prior to 2003, the Catholic Church ran the Ewaso Primary School. Some kids made it to what amounted to a parochial school, but only a few parents could afford to let their children attend classes instead of herding goats or cattle. Free public school education changed the paradigm of what the future might provide. The system isn't perfect, but there are qualified teachers, basic supplies, and in most public schools, there are enough books to go around. Many schools also enjoy the support of various not-for-profit groups that enhance food security and provide scholarships for hard working and gifted students to move on to paid secondary schools. Again, it's not perfect, but progress has been made and the future for near-universal literacy and educational opportunity looks bright.

NOTE: There are many edible roots, plants, and fruits in the bush. Those available for consumption in the wilderness near Ewaso Village include Lanai and Lamuriaki (fruits) and Laingudai and Lawai (roots). The Maasai name Leboo means "born in the bush."

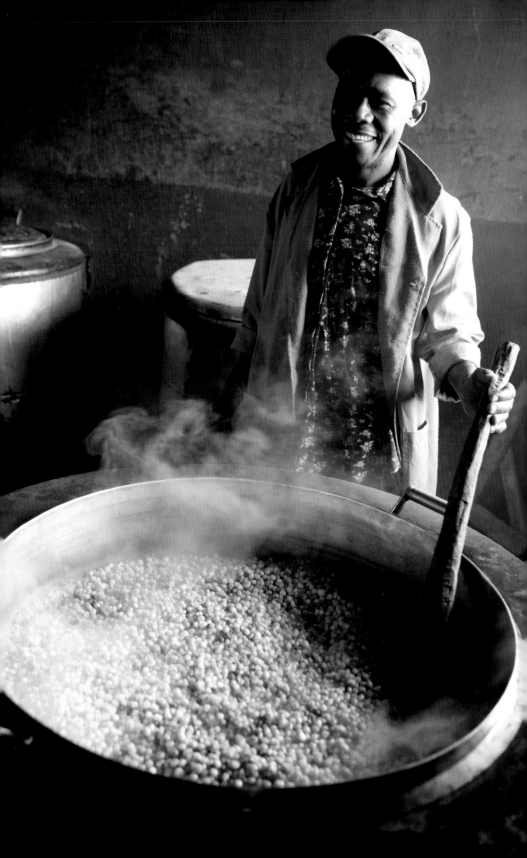

Leboo, Born in the Bush

Near the old bridge,
three warriors find baby body
licked clean by hungry dik-dik.

Warriors are meant to hunt,
but they find no mama,
just sandy placenta
dried by savannah sun,
and swirled inches
of umbilical
nibbled
by spiny mouse.

Soon enough, Leboo learns
the ways of an orphan:

silence
distrust
hunger
strength

and struggles with:

clarity
charity
sadness
shame.

Like leopard and lion,
camel and crane,
Leboo learns
to forage for food
from bush and river:

lanai
lawai
laingudai
lamuriaki.

Years go by.
Leboo becomes a witness.
He sees:

privilege
poverty
pride
potential.

Leboo's voice was stolen
long ago by bush spirits
in the sunny
hours after birth
with mama gone
and tears drying
on tiny wrinkled face.

Silence is a skill.

More years go by.
Leboo the school cook learns:

porridge
potatoes
beans
bread.

On most days at noon
eight cement schoolrooms empty
two hundred and thirty-four
hungry bellies…
a few distended.
As orphan, cook and witness,
Leboo sees
a hunger cramp
in a child's shuttered eyes.
Good teachers look away
when Leboo scoops
an extra spoonful
for the special ones
who need
a slow healing.

Like baby in bush by bridge,
Leboo sleeps each night
under spirit stars

fading
glowing
shooting
circling

like hope
and dreams
and life.

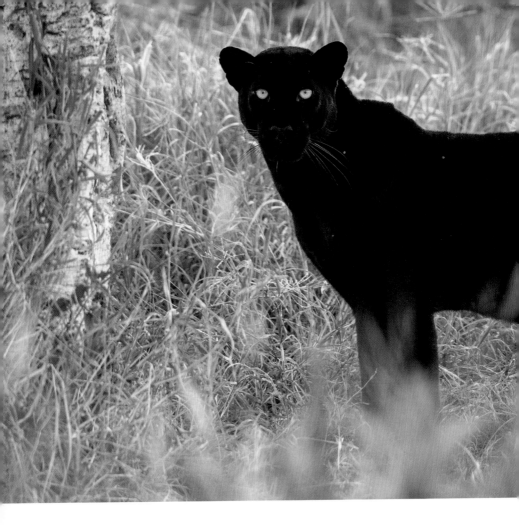

LETOLUAI, LEOPARD HUNTER

Early in 2019, members of a research team for the San Diego Zoo heard reports from villagers in Laikipia County of a black leopard roaming in and around the Loisaba Conservancy and Ewaso Village. Black leopards had not been spotted in East Africa for more than one hundred years, but the mythology surrounding the power and influence of what is also known as a black panther made its documentation as important as any wildlife study of the past decade. The hit movie *Black Panther* helped fuel the curiosity and media frenzy surrounding its documentation. Was it real? Where was it? How many were there? Questions about the local return of an animal some consider a predator to their livestock and others consider a symbol of strength and resilience raised expectations, worry, and curiosity.

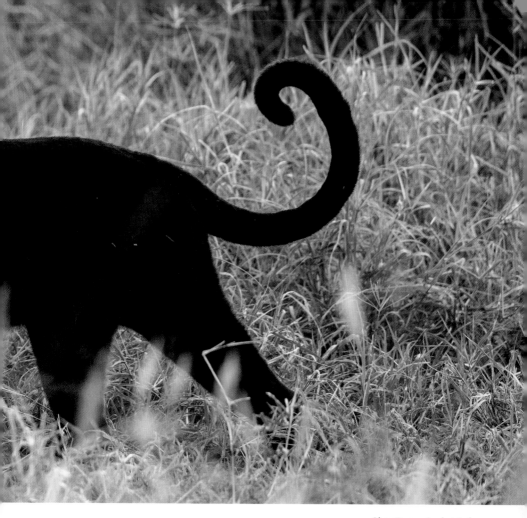

Photo Courtesy: Letoluai Ambrose

With limited funding and a casual reliance on the grit and intelligence of a local field biologist with no college education, hopes of a black panther "rediscovery" were modest at best. But 26-year-old Letoluai Ambrose had a few things that many imported field biologists didn't. That is, experience, perseverance, contacts, and an outgoing personality that has served him well in the Ewaso community. Ambrose came of age in the same wilderness that surrounds Ewaso Village. He knows villagers and nomadic herders of all ages as well as the many distinct characteristics of the bush. With devotion to a single mother and a handful of half-siblings he helped raise, Ambrose was highly motivated for success.

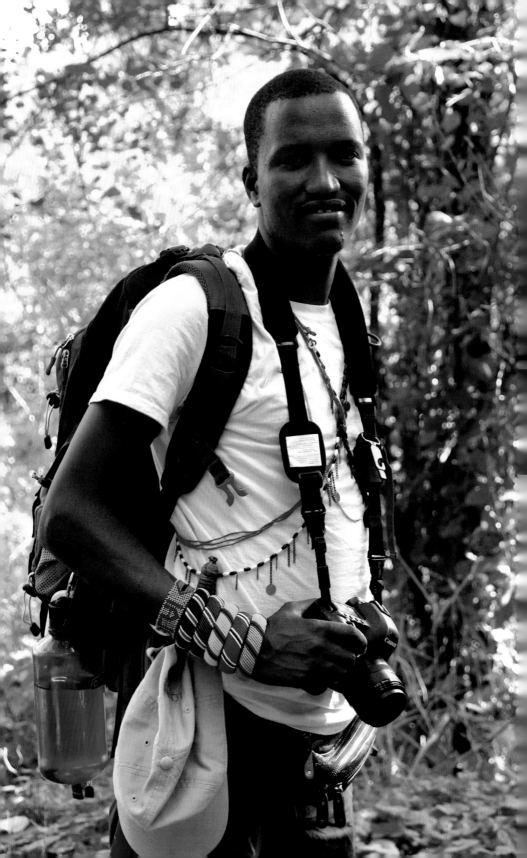

Using a series of camera traps baited with Chanel No. 5 perfume, Ambrose spent several days and nights planning, baiting, and watching. Then, in February, 2019, the first of many curious movements triggered an infrared camera. The dark, almost indistinguishable backside of a black leopard was captured during a midnight visit. The bait had worked. During the next few months, Ambrose and a team from the San Diego Zoo were able to document an entire family of black leopards with still photos and video footage that celebrate the resilience of wild animals to survive as they struggle against forces of economic expansion, including ranch, road, and housing development, power, mining, and climate change.

I first met Ambrose when he was a student at Ewaso Primary School. He claims he was inspired to pick up a camera after seeing a 6′2″ white guy with long blonde hair photographing his village and sharing funny stories with teachers and kids. Ambrose remembers two things about my visit. First, I had two cameras and one had a very long lens. Second, I told his class that I lived in a faraway land where snow falls three or four months each year, just like the white stuff atop Mt. Kenya.

Today, because of his black leopard research in Loisaba and Mpala conservancies as well as his tireless work ethic, Ambrose has joined the freshman class at Africa Nazarene University in Nairobi where he's studying natural resource management. Early in 2020, Ambrose was also granted a research fellowship with National Geographic. Participation in the leopard fieldwork also helped Ambrose obtain an internship in the United States with The Duncan Group as well as his first visit to the San Diego Zoo.

Letoluai, Leopard Hunter

Part One

Since the first white hunters,
black leopards of Laikipia survive
only in memory of Maasai elders.

A century has passed.
Families have survived
and thrived,
struggled and failed,
lived and died
and lived again.
They are timeless and temporary
like rain that evaporates
before it can nourish the dry earth.

Roads were built,
and borders
redefined with lines
and fences.
Climate changed,
stories replaced stories,
and truth became
as complex as nature.

Only the need
to move the herd
is constant.

Part Two

At dusk in Mpala,
a teenage boy walks alone,
watching, touching,
tasting, feeling.
He is Letoluai:
warrior,
hunter, seeker,
driven by desire,
decision and destiny.
Like a steady, silent giant
on a journey guided
by the patterns of stars,
he leans slowly in
to a crevasse
of igneous rock
and balances his body
with hands held strong
on the smooth black walls.
He has come to listen
to the wisdom
of ancestors echoing
through the tunnel of wind.

Time goes by,
and a hazy half moon
shepherds his search
along trails he has known
since boyhood.
Elephants graze in half sleep
driven by repetition
of trunk and tree,
trunk and tree.
Slowed to silence by slumber,
dik-dik's dream
as if only dreams are safe.
Lions yawn, ignore, and yawn.
Zebra mare stiffens, sniffs, snorts.
Eagle Owl watches from treetop
without judgment
as Letoluai kneels
and brings his steady gaze
to the soft sand.

Paw prints.

His fingers
circle the rings
of pad and toe
confirming all the things
the print is not –
dog, lynx, lion, caracal, fox.

Can myth become fact?
he wonders.
Letoluai searches
for hair, scat.
What is proof?
He waits for daylight
and follows tracks to tree.

Letoluai, Leopard Hunter

Part Three

Black leopard hunts in darkness
– wildebeest, gazelle, impala, springbok –
dragging their mangled bodies
to tree limbs
where he sits
high above the savannah,
feasting, stretching,
napping, eating again.
Focused and aware
like a sentry forced to action,
black leopard is singular and steady,
above a lion's willingness,
above a rodent's reach.

At dawn, Letoluai finds
the sturdy acacia tree
with carcass at its roots.
The warrior wonders,
plots, and plans a return.

Traps are set.
Letoluai baits
and waits.

At darkness
on fifth night
slow movement
triggers shutters,
and cameras
snap!
snap!
snap!

A mile away at river's edge,
the warrior sleeps
in a sling between
two trees.
And in his waking dream,
two shadows, startled,
react and run.

With a warrior's steady silence,
Letoluai rushes to the acacia tree
and in the stealthy snare,
images bear
a truth not known
since the time of great grandfathers.
Maasai spirit soars,
with proof of black leopard,
framed like king and queen
on their royal mission.

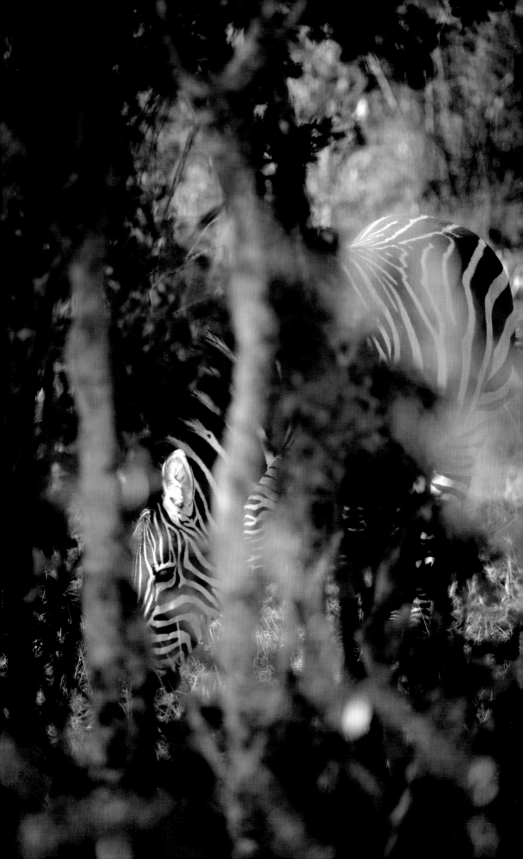

BY CERTAIN MAGIC

As a photographer, I'm known more for images of people than wildlife or landscapes. Those who specialize in wildlife images often feature the meat-eating predators if only for the dramatic impact they have on life around them. Carnivores swoop in from above on the busy and unsuspecting, they leap through the air like fast-flung spears to startle and strike, or they sit like a still life in camouflage colors waiting to snap a neck or lay a poisonous bite into flesh. We have all seen these images, and they can remind us of many things we live with as well: the immediacy of an old friend's death, the suddenness of a foot on brakes as a truck swerves into our lane, a slip on black ice, or the freakish turbulence that jolts us from the pacifying movie playing on the seatback in front of us. In the wild, predators almost always win.

Photographing people is, for me, about creating a relationship. It's not without uncertainty, but generally, photographing people is about projecting my curiosity with a smile and the hope of finding kindness and a smile in return. During visits to Laikipia County, my inclination is to watch women beading, to witness a teacher as she challenges her students, to walk alongside a shepherd boy or girl as they manage their herd, or to listen to an elder as he weaves stories or plays the nyatiti around the fire. Those are the moments when I feel truly comfortable, the moments when my camera becomes an easy and welcome extension of who I am.

Still, on every visit, I also find myself sitting on the flattened seat of a beat up SUV exploring wildlife that far outnumbers the villagers. I'm not a "sit in the blind" type of photographer, so when I am on safari, I find myself drawn to creatures whose movements and patterns make sense to me. It's a different kind of ballet, less dramatic, and more like the awareness and ease I enjoy with people. Instead of hiding myself like a predator, I'm happy to wait for the light to be just right while exchanging glances with elephants, monkeys, zebra, various kinds of even-toed antelope and, of course, giraffes. Why giraffes? Well, I love their awkward trot, and the thoughtful, swaying movements of their necks as they inspect each other's torsos. I love the rhythmic swing of their heads as they approach the treetops to eat. They're unique among the wildlife of Africa. With the graceful movements of a soaring hawk or ascending fish eagle, they glide through the savannah comfortable with the pace of soft wind. I'm not big on anthropomorphizing, but giraffes do seem aware of their beauty in the same way a Hanoverian calculates its delicate movements through an Olympic dressage course but with this simple difference—giraffes do it all on their own.

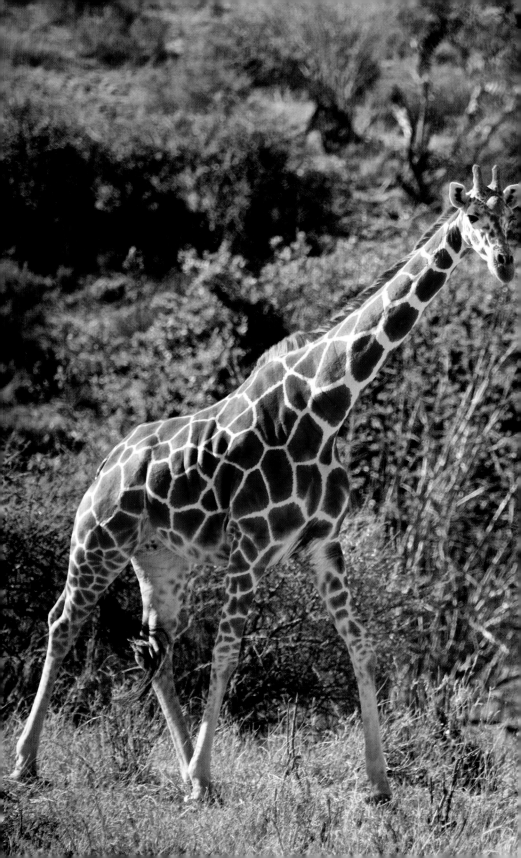

by certain magic (the giraffe)

as if by certain magic,
your neck reaches
nests in treetops
where eagle eggs
lie untended,
yet you come
for leaves.

line by line (the zebra)

hidden as dead branches
in a dying grove,
you are like lines in the bush,
unnoticed except by scent
of scat and sweat,
and wise enough
to let dik-dik
take the heat
of predators.

searching for gods (the impala)

i imagine you sleeping,
legs tucked beneath torso
and horns rising high
like a divining rod
searching the cosmos.

FIRE ON KIRINYAGA

Even with rapidly depleting glaciers and a changing climate, climbing Kenya's Mt. Kenya and Tanzania's Mt. Kilimanjaro remains a big part of eco-tourism in this region. Each mountain has its draw and, with some thanks to the popularity of Ernest Hemingway's short story *The Snows of Kilimanjaro*, Tanzania's great volcanic mountain is on the bucket list for many North Americans. Hiking at high altitude is something I do regularly, and in 2004, I decided to check the Mt. Kilimanjaro box on my list. From a distance, Kilimanjaro looks like an inverted top on a flat, vast surface of savannah. Its singular, icy peak is visible from as far away as one hundred kilometers. Climbing Kilimanjaro only furthers the top metaphor because in order to

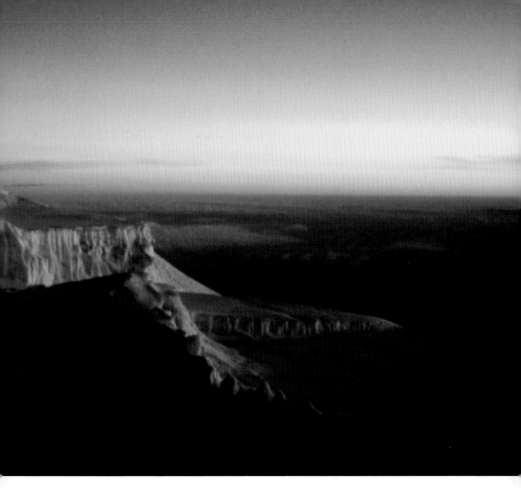

Summit of Mt. Kilimanjaro – 2004

summit, most groups ascend to about 15,000 feet in elevation, then spend the better part of a week circling and circling the mountain in an effort to acclimatize.

Trekking is a spiritual experience for me, and with minimal self-analysis, I can attest to the notion that steady breathing and short, focused steps repeated over several hours help energize my body and mind with what the Hindu call Prana. The life force. Stress disappears while trekking, thoughts are accepted for what they are—curious instead of punishing—and emotions become as even as a perfectly heated cup of coffee. Not too hot, not too cold, just right for drinking them in.

The challenge of summiting Mt. Kilimanjaro is real. Eighteen people started our trek with smiles and slaps on the back, but only five of us made it to the summit. The snows that Hemingway referred to nearly one hundred years ago are mostly gone due to a combination of climate change and clear cutting of forests near the base of the mountain. I enjoyed the meditative pleasure of the trek itself, but I found the summit dreary and lifeless in the way potatoes or vegetables look when they've gone limp from too much refrigeration. Climbers express joy at their achievement, cameras snap around gatherings near the signage at the peak, but the haunting beauty I'd hoped for didn't exist. The vistas are flat and dimensionless, and nearly everyone I know who's made it to the peak comments about the obvious loss of ice. In other words, Kilimanjaro felt, to me, like a dying mountain.

When we returned to camp, I asked one of our local guides from Arusha about the spiritual history of the mountain. Surely, I suggested, the storytelling skills of novelist Ernest Hemingway must have been inspired by something other than glaciers and a leopard. His blunt reply, however, shut me down quickly. "There is no spiritual importance to this mountain," said Abde. "It's just an old mountain." To the amusement of my climbing friends, I closed my pen inside my journal and took a deep breath. There had to be some story, I thought, some mythology behind the tallest peak in Africa. So I continued the conversation by asking, "so why do you climb it then?"

His answer was even more direct. "We need the work," he said. Abde had been to the summit of Mt. Kilimanjaro more than one hundred times, yet for him and his fellow porters and cooks, summiting was no more difficult than taking a group for a walk around the block. I shook Abde's hand, thanked him for the journey, and as I walked away, he added, "If you're looking for gods, you should climb Mt. Kenya. Mt. Kenya has gods."

I have yet to climb Mt. Kenya, but I have driven around the base and photographed wildlife in nearby Ol Pejeta Conservancy. To me, Mt. Kenya is prettier than Mt. Kilimanjaro, and by many accounts, it's a more difficult and dangerous climb to the summit. The ecosystem around Mt. Kenya is more diverse and irregular than Mt. Kilimanjaro, but what each mountain shares is their impact on the weather, agriculture, and culture of the surrounding area. Both mountains have safari lodges and conservancies

within the shadows of the mountain. Abde was also right about the gods. For most tribes near Mt. Kenya, the mountain is referred to as Kirinyaga. It's believed to be the birthplace of more than just cows; it's the birthplace of human beings. The summit of Kirinyaga is where Nyaga (God) first populated Earth. The first human believed to ascend to the top of Kirinyaga was called Gĩkũyũ, a name that also refers to the Kikuyu tribe of today.

Today, there are about seven million Kikuyu people living in Kenya and, as the country's largest ethnic group, they represent about seventeen percent of the total population. Many Kikuyu live on the southern and western sides of Kirinyaga, and many make their living from farming. Other tribes that live in the shadow of Kirinyaga include the Embu to the southeast, the Ameru to the north and northwest, and further to the west and south, the Maasai and Samburu people.

Kirinyaga is roughly one hundred kilometers from Ewaso Village, yet it's easily visible on clear days. While on a visit to Ewaso Village in January, 2018, a forest fire in full, dramatic blaze circled the center of Kirinyaga at about 7,000 feet in elevation. At night, the fire looked like a halo or a vibrating white hula-hoop circling the waist of the enormous mountain. With a good pair of binoculars, we could see the movement of flames on the steep, windswept inclines. During the day, smoke trails stretched like jet streams above the summit and fanned out to the east.

According to Paul Lebeneyio, most fires occur on the mountain during the dry season or a prolonged drought. Their typical pattern is to move up or down a section of mountain vertically, but this was the first time he or anyone in the village had seen a fire circle the mountain horizontally. Their fear, verified by local park officials, was that the fire could permanently destroy plant and animal life indigenous to that particular elevation. The 2018 fire lasted several weeks, and the long-term impact is yet to be determined.

Fire on Kirinyaga

As night sky
turns violet in the east,
Maiyo wakes me
to share witness.

We stand in silence,
watching together
as an amber ring of fire
circles God's mountain,
a glowing coronet
stuck in place on mountain belly,
vibrating to sounds
of thunder, crackle,
sizzle and spit.

This is new to me, I tell Maiyo.
We see a place of death and devastation,
but from the distance of Ewaso,
there is only stark, radiant beauty
as glowing strands of pink smoke
soften the jagged peak
like a silk scarf diverting attention
from the chaos below.

I am a visitor, and Maiyo knows
that in my ignorance I am slow to see
the loss of life on Kirinyaga –
trout, cricket, moss, thistle, lizard, leech –
their existence measured
by the elevation they call home,
their air just thick enough,
cool enough, warm enough
to evolve like us
from the dust
of a single star.

We watch through hours and days
as flames feed on the last gasps
of trees and shrubs sucked dry
by heat, wind, and pressure
until a thick brown belt
tightens around the bulky
waist of the burning mountain.

At twilight by a fire of our own,
Maiyo and I chew on goat fat
that gives us life.
We hear bats flap above us,
the harmony of cicadas,
village dogs barking
their fear, their warning,
their dominance and disdain.
When I ask Maiyo what will happen
he fills his lungs
with a calming breath,
pokes our dying embers
until, at last, he says,
We shall see.

ESIANKIKI, STAR SCIENCE

More than four hundred students attend Ewaso Primary School on a regular basis. Some students walk to school daily. Those who come from further away board at the school for days or weeks at a time. Boys and girls are separated into one of two modest cement buildings with short metal bunks lining each long wall like a military-style dormitory. Local administrators do their best, but resources for those who board are limited by a government that often turns a blind eye toward rural schools. Not-for-profit groups like the Loisaba Community Conservation Foundation help with private donations, but there's rarely enough food and basic academic supplies such as books, paper, pens, chalk, and desks to meet the needs of every student. Sharing becomes a core value for students—it's the norm—and it creates camaraderie and equality among students that I've never seen in public schools in the U.S. There may be competition in a science fair or spelling bee, but the day-to-day classroom studies are often collaborative. It's not uncommon to see three students crowded together sharing a single workbook or computer.

For teachers and school administrators, remote rural schools are viewed as a hardship post. Many teachers receive their degrees at larger universities in Nairobi, Mombasa, Kisumu, or Nanyuki, all bustling cities that have little in common with a village like Ewaso. Accommodations on school grounds are usually bleak with limited food supplies and a difficult social life. Even the customs and cultural practices associated with a teacher's upbringing and family can vary widely from those of a rural community. The joy of teaching has its rewards, but it can be both lonely and, after school hours, boring.

During my first journey to Ewaso Village, I was invited to visit and photograph a few classrooms and to share my background and stories with students in a 4th-grade class that was studying basic science. As I often do with kids in equatorial zones, I passed around a few photos of where I live—but with a twist: Snow! Winter! Cold! And frozen lakes! The kids were aware of the ice atop Mt. Kenya, and some had heard of Mt. Kilimanjaro's glaciers, but I was the first person they'd ever met who actually lived in a place where snow falls for months at a time. The idea of skiing was a head twister, and pictures of me walking in snowshoes brought on the giggles.

While I was talking, the teacher watched, smiling, with a three-year-old girl in her arms. When she resumed her lecture, I discovered that her nine-year-old son was in the class, and that her daughter was simply part of the class. To the toddler, the classroom was as familiar as a playground. She roamed among the students, put her head on laps and shoulders, bounced an eraser on the floor near the blackboard, and crawled into her mother's arms when she needed more attention. During recess, I found out that teaching wasn't new for her, but being a single mother was. Her husband had left her as the sole provider and was nowhere to be found. When she took the assignment at Ewaso Primary School it was with the idea that her two children would be safe at her side—literally—and that they would be able to live with her in the community.

When recess ended, the students reassembled. There was poking and laughter as they entered class, but playfulness ended when they sat down. During the next half hour, I moved around the room photographing students and was pleased to see the abundance of respect they had for their teacher. She was focused, direct, and clearly knowledgeable, and even while placing a calming hand on her daughter's head or kneeling to retrieve chalk from her tiny hand, she managed to make teaching science a graceful interaction. From the shiest kid in the back row to the hand-raising know-it-all in the front, the students understood the challenges their teacher faced. Drawing a solar system on the blackboard with one hand while holding an energetic toddler with the other was what it was—normal.

NOTE: The 4th-grade teacher I met at Ewaso Primary inspired the teacher portrayed in the following poem. For the poem, I gave her the Maasai name Esiankiki which means "young maiden." Olamayian translates into English as "lion." Leboo, who reappears in this poem, means "born in the bush." Naserian translates from Maa to mean "the peaceful one" in English. Lemayian means "the blessed one" in English. Naisiae means "the hard working one." Kirinyaga refers to Mt. Kenya. The Milky Way is a spiral galaxy that appears in the unobstructed night sky and includes as many as 100 billion planets along with the solar system and a planet that many call Earth.

Esiankiki, Star Science

Part One – Homework

Her favorite lesson is coming:
star science.
Students see the shift
in her stride.
Something is amiss
as their teasing tugs
and nervous pushes
create no comeback.

"Tonight," says the teacher,
"there will be homework!"

Bully gulps. New girl
fitting in rolls her eyes.
Twins feign surprise,
and three brothers
on the back bench
moan as loud as cows,
for they have a herd to tend
and no nightlights for reading.

"Before you go to sleep,
lie outside in a safe spot.
Look up, breathe in, breathe out.
See patterns and shadows,
serpents and sextants,
lions and lizards.
Then count and count and count.
Tomorrow we will talk."

The thought of counting stars
brings quick relief, smiles,
shuffling feet, biting lips,
reflection, awe, and wonder.
Naserian packs her pencils
in a tiny pouch pondering
questions of her own:
maybe what is up there is not here.
Lemayian straightens
the thin black tie
his grandfather wore to work
day after day at the tourist lodge.
When he closes his eyes,
a vision of star clusters fills
his mind.
Maybe there is water out there,
he thinks, *maybe the cows*
are full and fat.

Part Two – Her Journey

For Esiankiki,
stars are rhythmic, enduring,
a light to be counted on.
They are like seeds
planted in thick black soil,
and nourished by the sacred space
inside her and beyond her.

Ewaso Village is a stop
on a long journey.
Behind the humble smile,
nervous rubbing of hands
and tapping of feet to a song
only she can hear,
Esiankiki is a constellation,
a cluster of related things:
an adult who doesn't know her age,
a mother who lost two babies,
a wife who ran in the night
from a husband
with wounds of his own,
and a teacher who loves enough
to read and write and teach
and dream.

There is still hardship,
but no more than before.
She sleeps on stained cushions
and folds them away each day
behind her teacher's desk.
She cooks over a tiny fire
behind the back door,

and eats from a single plate
washed after every meal.
She bathes with river water
and shoos flies
with a paperback.
Food is scarce and dull
but Esiankiki is nourished
by each child's inquiry,
by their need to play and pretend,
by the chaos of a cobra in the well,
a stray dog feeding her pups
near the woodpile,
prickly pear flowering
by the rusted gate,
elephants breaking fences,
and the shiny pole
waiting for a flag.
She is nourished
by the night sky,
and stars beyond stars.

Part Three – Dawn

Roosters and dogs
break the silence
as if calling all hands
to rise and shine.
Esiankiki stands beside
the teacher's tilted toilet,
her forefinger, delicate,
elegant like the stem of wild orchid,
sliding soap across her cheek tops.
She studies her smooth,
sudsy face in a hand mirror,
feels the depth of her curious,
russet eyes, and she wonders,
Am I bigger than one place?
Am I endless?

Part Four – Star Science

At her desk before class,
Esiankiki closes her eyes and tries
to see the night sky.
But in daylight, there is only
the loose knot of empty desks
as old and broken
as the life she left behind.
Yet I am like a shooting star, she thinks,
leaving behind a trail of light.

A bell clunks, its echo long departed.
Students gather – all but Naisiae
who tends to her family's herd
on the slopes near the river.

"Nebula?" asks the teacher.
Gulps and shuffles.
"Who knows this word,
Nebula?"
Sniffs, pursed lips,
heads buried in books.

There is no PowerPoint,
no projector, just a few torn pages
from *National Geographic*
taped to a chalky blackboard.
She taps the broken pointer
near the cracks on hollow slate
until Naserian rises, presses
nervous hands to straighten
her pale uniform, worn and torn
by sister and sister before her,
and says, *"Nebula. A gas…but like dust."*

"Yes!" says the teacher, *"a nebula
is an interstellar cloud, expanding
like the swirl of cumulus
that hovers above Kirinyaga.*

*And who knows the name
of the red planet?*

The boys in the back,
jump, smack shoulders,
"Mars!"

"Yes!" she says. *"A planet red
like the clay on river bottom.
A planet cold as midnight,
more distant than Nairobi."*

"The largest constellation?"
She taps and taps against
a flat, faded photo
from the old magazine.

No one rises.

"Hydra," she says.
*"Discovered by Ptolemy
in the second century!
Who is Ptolemy?"* she asks.
"When did he live?"

She sees the blank stares
of children who have had too little
for too long, and takes it in.
The second century is before

the river ran dry, before
lions left the savannah, before
white faces came to own the land.
Time in Ewaso is measured by
water, earth, sky.

*"Who knows the constellation
that looks like a lion?"*
Confident from his studies,
Lemayian jumps to his feet,
"Olamayian!"

Esiankiki lays her pointer
on each of Lemayian's shoulders
as if proclaiming knighthood.
"Yes." She taps the outer reaches
of the black slate, then continues
tapping into thin air as if to say…beyond.
*"Olamayian is out there, a lion whose
light has been seen for centuries,
a light that existed before my mother
and your father, and before their parents
before them. The light we see from Olamayian
the lion is older than sand, older than water.*

*"The light of stars is our path to the river,
our crossing of savannah, our connection
to tusks of elephants and rhino, to stripes
of zebra, to the fleet feet of dik-dik.
In the bush we may walk alone,
or feel alone, but in the night sky,
each of us is as infinite as star light,
cells in a body that has no end,
yet shining as one and visible to all,
with pulsing, reflecting energy
that makes us whole."*

This tiny classroom
filled with fourth graders
stares in silence at their teacher,
comfortable in their confusion.
She has left them with the energy
that moves through hands
held in a circle.
Naserian rises, uncertain but curious,
"Do we go to the stars when we die?"
Esiankiki feels the deep breath of life
move through her body.
She is finally where she needs to be.

"Perhaps," she says. *"We are
Olamayian and Hydra,
Orion and Pegasus.
Perhaps we are before now
and after now."*

Bare brown feet
kick the half-filled ball
through a broken goal post.
Fingers brush and braid
blue and yellow beads
into the new girl's hair.
Teachers mingle, laughing,
planning, dreaming, caring.
Hungry flies circle
the plastic honey bucket
as Leboo scoops spoonful
after spoonful
onto chunky clumps
of day-old bread.

AT THE AIRSTRIP

Nairobi, Kenya 2016. Spectators look on as flames kick and swirl around the decaying remains of 6,500 elephants and 450 rhinos. The faces of onlookers contort with anger, sadness, and confusion over the sickness of greed and depravity that inhabits the spirit of those who murder these animals for their tusks. Like a battle of words that can only end in disharmony and disconnection, the fire is a slow, hopeless burn.

Speaking to an international assembly gathered at Nairobi National Park, Kenyan President Uhuru Kenyatta breaks the silence with words that ring true for nearly all Kenyans: "For us, ivory is worthless unless it is on our elephants!" But that's not true for the few violent poachers whose hands reek with dry blood and whose souls are fed by dirty money. The audience in Nairobi has assembled to witness the largest ivory burn in history, a spectacular yet controversial effort to stop poaching and destroy a product that when reduced to powder is more valuable than gold. According to *National Geographic*, the intentional fire ignited 105 tons of elephant ivory and 1.35 tons of rhino horn from animals that had been poached and killed for tusks, and then confiscated by authorities before the poachers could get their product off the continent. There have been many similar burns in Kenya and elsewhere, including one in Laikipia County several years ago.

Elephant and rhino poaching throughout Africa is lucrative, and the illegal, black market trade in ivory remains considerable. The long-term survival of elephants and rhinos is severely challenged by international criminal teams that run like a syndicate. The money circulates to the top, and the desperate men in the field who perpetrate the violence are paid very little to betray their values and their cultures. Many governments have reacted with severe punishments for those who get caught. Corruption at various levels of government in Kenya and elsewhere continues to make ivory trade possible. It's no secret that China has been the biggest consumer of this death trade, but recent decisions by the Chinese government to limit ivory trade at the border show some promise.

Still, at the time of this writing, poaching ivory remains one of the most profitable yet despicable practices known to humankind. Despite using drones and a fleet of dedicated rangers to detect and arrest poachers, the

Ol Pejeta Conservancy near Mt. Kenya has been hard hit. Ol Pejeta is among the most visited safari sites in Kenya. Tourists create fond memories photographing grazing elephants and rhinos trotting across the vast savannah in the amber warmth of late afternoon sun. Snapping shutters, excited whispers, and the low hum of an idling engine should be the only sounds humans leave behind in Ol Pejeta. But the body count tells a different story. On far too many nights, gunshots pierce the silence as unsuspecting rhinos and elephants fall victim to the callous wrangling of machetes and saws.

There's a cemetery in Ol Pejeta for the bodies of murdered rhinoceros. Their bodies are marked with tombstones that tell the date of their death and the manner in which they were killed.

At the Airstrip

Celebrities arrive.
Their helicopters
and private planes
park along the gravel,
sand, and thirsty bush
like cans lining a shelf.
Beyond them,
the gaze of gazelle,
slow sprint of zebra,
low flight of fish eagle,
and the floppy jog
of ostrich.

Ivory, the creamy
curved trophy
of dead elephants
brings them here.
They have seen pictures
of rotten carcass, blood
dried the color of death,
and they know
the shame of greed.

Ivory, precious as gold,
sold like women
and children are sold
into a dark world
of princes, sailors,
soldiers, merchants.
Men.

Soon there are cameras,
papers, podcasts,
websites, blogs;
newscasts broadcast
the blazing tower of tusks,
and flames flicker
on cheeks of actors, athletes,
models, bureaucrats, presidents,
and the many failed ministers
of conservation watching.

No elephants attend. The living ones
are eating, somewhere far away,
licking wounds, grieving losses,
as their numbers dwindle.

In a bedroom in Bali,
a kitchen in Canada,
a market in Morocco, people
talk about the loss of life
but do nothing, really.

CIRCLE OF FIRE

The dirt road that passes through Ewaso Village carries more people than cars, more goats and cows than motorcycles. It's a passageway for shepherds, and a footpath for school kids and over-burdened women shouldering loads of laundry and firewood. It was on the road to Ewaso Village that my Maasai friend Robin first heard the well-worn photographer's phrase, "Stop, please stop!" Today, my Maasai friends still tease me with those words before we pull over so I can jump out with camera in hand. More than a decade ago, it was on this dusty, rutted stretch of road that I made my first image of a Maasai Warrior. He was a young man of about seventeen dressed in traditional Maasai clothing. Each Maasai has his own style, but most warriors wear some type of rubber or leather sandals, a brightly colored robe around the waist or over the shoulder that stretches to just above his knees, large round earrings, and a neck full of colorful beads.

A herder by trade, this smiling teenager carried a machete and spear, and both he and his dozen goats were blanketed by the soft magic light of a haze-filtered sun. His smile was infectious, and he giggled at the unexpected attention as I snapped his image. Focused on my own technology and finding the right light, I was at least two minutes into the spontaneous photo shoot before I spotted the cell phone tucked into his tight-fitting leather belt. Ah, I thought, "I get it." My own smile of recognition is etched in memory—the Maasai make a clear choice to protect their traditional lifestyle while embracing just enough technology to stay connected to family, friends, and the modern marketplace. Most news is still local and spread by word of mouth, but several of my Maasai friends do use Facebook and Instagram.

Today in Laikipia County, most people make a subsistence living at best. Poverty, poor health care, poor maternal care, illiteracy, unemployment, and homelessness are significant problems that the government has struggled with for decades. At the same time, there's a deep appreciation among the Maasai for modern education and a desire for the basics of food, water, and shelter that are fundamental to survival and quality of life.

Some traditions among the Maasai are controversial, including both female and male circumcision, and polygamy. Female clitoral circumcision, which is often referred to in the West as "female genital mutilation," generally happens to girls at the time of puberty and is administered by midwives. Boys are also circumcised at the time of puberty, and with both boys and girls, excruciating pain is a significant part of their symbolic rite of passage into adulthood. No painkillers or anesthesia are used and, in the case of boys, making a sound or screaming out in pain is considered unacceptable. If a boy screams, he will not become a warrior. The price of shame and being ostracized by the tribe is so high that most young people do as their parents did before them. They swallow hard, steady their breathing, and let the streaks of tears tell the story of their suffering.

During the past decade, I've witnessed a willingness on the part of several Maasai elders to learn more about the health consequences related to circumcision, especially those practices that impact women and girls. They're aware of and concerned about the criticism of their practices, but they're also aware of the ignorance of many Westerners regarding their desire to protect their cultural heritage. Today in Ewaso Village, there's a genuine effort to educate local midwives and to help inform villagers and rural members of the Maasai community about the long-term health risks associated with female genital circumcision. In many cases, there's a willingness to alter or stop the practice. Still, as many of the rituals associated with rites of passage are centuries old, the educational process remains a slow one.

Many of the young men and women I've talked with support some of the rituals associated with entering adulthood, including techniques to achieve self-reliance, self-confidence, and overcome fear.

NOTE: In the Maa language, the name Lemuani means "the blessed one." Nalangu means "born in the time of rain." Enkai is abstract, but translates into English as "God." The Maa word for warrior is Imurani.

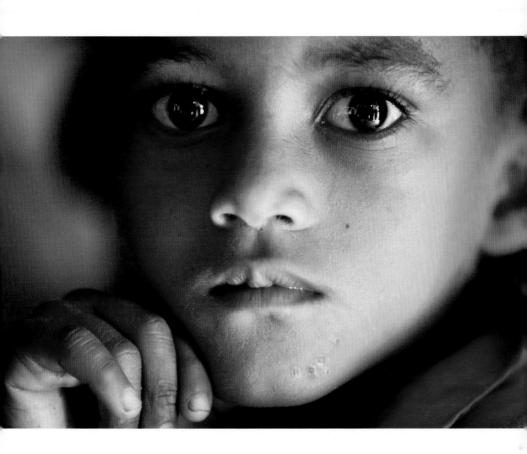

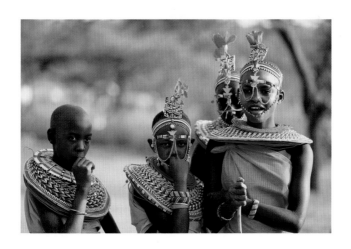

Circle of Fire

In the circle of fire,
nyatitti stretches across earth,
strings stiff and silent
old wood resonant
with echo…echo….
Young warriors listen
to Lemuani, husband,
father, wisdom keeper:

There are lessons in savannah
each day,
spotting snakes
and scorpions,
tracking lion
and leopard,
listening
for low rumble
of elephant feet
that guide
our search
for water,
shelter
from storm
and burning sun.

In the circle of fire,
young warrior
bodies tighten
with flames of wonder,
anticipation of rites
of passage as
ancestor spirits speak
through the blessed one:

Imurani survives knife
without sound.
Imurani grows to man
with courage to care
for wife, son, daughter,
for herd and village.
For Imurani,
sun and rain are life,
mountain is wisdom,
moon is hope,
river is connection,
earth is past,
sky is future.

In the circle of fire,
the mirror eyes of Lemuani –
who has listened in the years
before these warriors were born –
dance with fire, spirit animals
rise through the darkness
sharing strength and sorrow,
life and death,
love and loss,
wounds and wisdom
of one thousand years.

In the circle of fire,
Lemuani is of two worlds,
the breath of ancestors
moving past stars until
their voices unite inside him.
He is father
confident in love
as he brushes and braids
his tiny daughter's hair,
cleans crystals of sand
from her forehead,
sets her tiny bottom
in the lap of Nalangu, mother,
keeper of faith, devotion.
Strands fall to shoulders
as hands twist braids
between thumb and finger
and weary daughter nuzzles
into crook of mother's
shoulder and breast.

In the circle of fire,
Lemuani breathes life
into embers,
flame catches trail of sap,
warms wife and daughter,
lights faces of young warriors,
intent, bold, ready to carry
the weight of family, village, tribe:

The spirits of our father's father
and our mother's mother
are with us
from the time their bodies die.
The stars they form take shape
of animal, tool, flower,
they tell us
when drought will come,
when to sing songs,
when to drink fresh blood
of butchered goat,
when to chew
kidney raw from belly
to nourish life inside us.
Their spirits tell us
when to follow water,
tend herds, feed family,
spear aggressor.
We are watched through
the eyes of Enkai, god, guide
who built Maasai like lion,
hunter, provider,
mindful of man,
sun, earth, river,
and like the pride,
we are strong together.

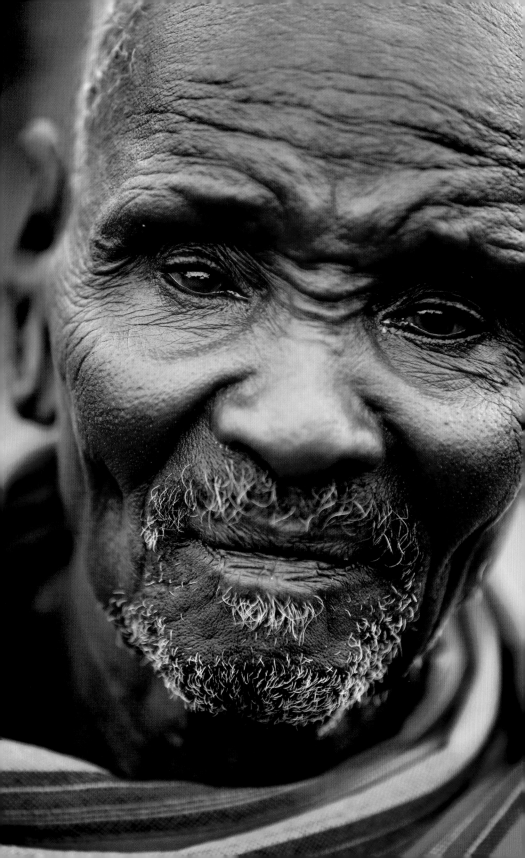

WATER, EARTH, SKY

"Would you like to slaughter a goat?" asked Paul.

After a decade of friendship with Maasai elder Paul Lebeneiyo and his family, my 2019 visit to Ewaso Village was the first time I'd been invited to participate in a ritual long associated with the Maasai.

"It would be an honor," I said.

Of course, I didn't tell Paul that I'd never eaten a freshly killed goat before and had no idea what to expect from the bloody ritual. But the offer showed his respect, and I was happy to return it to Paul by accepting.

The offer was extended to the group I was guiding and the initial response from my ten fellow travelers was an enthusiastic "yes!" During an afternoon of planning, Paul and his fellow warriors arranged for the goat and, as soon as the last trace of sun had left the horizon, the goat's demise began. I called my guests to join us near the bonfire, but their earnest enthusiasm had faded. Some were willing to eat barbecued goat, but I was the only one to attend the killing. Following a gentle but deadly incision with a sharp knife to the throat of the goat and the peeling back of facial skin to form a pool for the flow of warm blood, it was time to drink the blood. Two of my Maasai friends put their mouths directly into the small pool and slurped their mouths full.

"Would you like to try?" asked Paul.

It's become part of my job to participate in the spiritual ceremony I'm invited to document, and the slaughter of the goat was certainly spiritual for my Maasai friends. As they shared their gratitude for the sacrifice of the goat, my mind raced back to the slaughter of chickens I'd filmed in a rural Haitian ritual before sharing barbecued drumsticks with a Vodou mambo. I'd eaten pigeon in Kashmir, sheep's brain in Spain (served in the skull), snacked on wok-fried grasshoppers and sparrows on a spit in Burma, consumed bootleg whiskey in northern Afghanistan and, at the request of a drunken priest, I'd once had a five-minute dialogue ear-to-ear with a tarantula as my own rite of passage to be able to film a pre-dawn Vodou ceremony in the Haitian bush (the tarantula, I was told, gave me a thumbs up!). Still, I wasn't quite ready to drink warm goat blood from a dying animal.

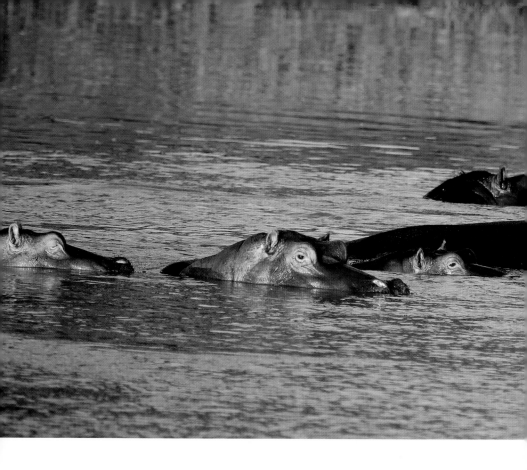

"I'm pretty busy here, Paul," I said. The need to film can be a good excuse for being present without participating. "You guys go on ahead without me."

Which they did. In no time, my Maasai friends had finished drinking the blood and begun butchering the torso. It wasn't long before I was offered the delicacy of a raw kidney, but again, I was busy documenting.

"I'll have to pass," I said. "This ritual is so great that I don't want to miss getting it on camera." Paul smiled, knowing it meant there was more for him and his fellow warriors. He also told me later that he, too, would pass if attending the ceremony with the Kikuyu or Luo or similar tribes because everyone has their own technique for slaughtering goats.

Once the butchering was complete, a small grill was placed over the bonfire and the barbecue began. The smells reminded me of a bratwurst cookout back home, and within minutes, my group of fellow travelers began showing up

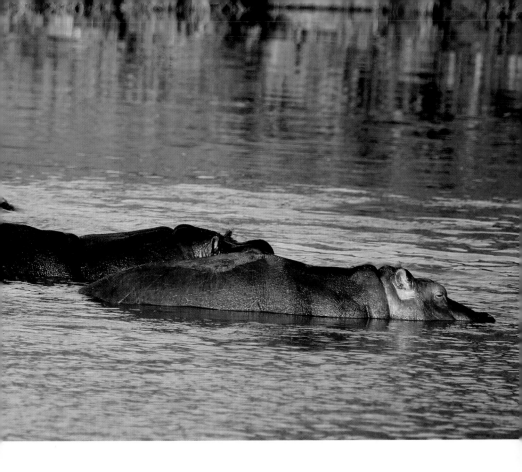

to enjoy the bonfire. With no moon, the night sky filled with shooting stars and slow-moving satellites more visible than anywhere in the light-polluted skies of North America and Europe. Robin plucked the strings of a nyattiti and sang folk songs he'd known since childhood. The companionship that emerged from two open-minded cultures brought together across oceans inspired laughter and encouraged curiosity. New friends from thousands of miles apart created lasting relationships that continue to this day. Perhaps born of respect for the dead goat, or simply inspired by our shared witness to its last breath, Paul and I began a discussion we couldn't have had without the trust and fondness born from numerous visits and quality time. What, he wondered, was my first experience with death?

It had been decades since I'd thought of my grandfather, but the question brought back memories of my first funeral and the open casket of a very dear man I'd known since birth. I was four, and Papa was dead. I remember him lying near the altar of a dank-smelling church with his rail-thin body tucked

snugly into a pressed suit I'd never seen him wear. His eyes were closed, and his lips were pressed tight against each other. "Is he breathing?" I asked. My mom, for whom thirty years with Papa seemed far too few, struggled to answer with anything more than a finger shushing across her lips. It had been just a few days since I'd crawled in Papa's lap and giggled as he mussed my hair and tugged my ears, so with my tiny head peaking just above the side of the casket, I watched for movement. A blink. A curl of his lips. He must be in there, I thought. But his solemn, forced expression said otherwise, because Papa would have smiled at me. Papa would have stolen my nose with his thumb and put it in his pocket. Papa would have found a quarter behind my ear. It was then that I knew I'd never sit on Papa's lap again. I'd never again smell the pipe smoke in the collar of his shirt. I'd never again feel his day-old whiskers rub against my tender cheeks.

As the memory of a dead grandfather came back to me, Paul and I shared our wonder at where life comes from, and where life goes. We mused about our consciousness, our souls. We talked about the bundles of love, joy, and sadness we carry on our backs and in our hearts. Like characters in a book, friends, family, lovers, and colleagues fill us and flow from us and, over time, little remains of their essence but a wisp, a memory triggered by song or poem, the minor chords of Bach or Barber, the sound of a particular bird, the scent of flower or spice, or the impossible lines of a sculpture, a portrait, or a play. Millions of people believe in an ancient story that the person who has died will soon sit for glorious eternity in the "kingdom of heaven" or in a cascade of misery rotting for perpetuity in the "fires of hell." For millions of others, including both Paul and me, death is just death. It's an ending without answers. Something may happen, and it may be grand and remarkable, but for now, we simply don't know.

Another way to interpret the question "what happens when we die?" is to answer it literally, as in, what happens to the physical body when we die. Is it buried? Burned? Mummified? Tossed in the Ganges? Dismantled in an anatomy lab? Sent off to sea on a flaming wooden boat? Entombed in a cave? Tossed in a crevasse? Or embalmed and propped up at the kitchen table for years to come? Yes, some cultures do preserve the corpse and include the dead body as a normal part of the family for decades, and others keep the skull of the dead relative on a shelf or an altar for as many generations as offspring will manage the remains.

The Maasai and Samburu communities of central Kenya live as practically and as close to the earth as any group of people I've ever met. I've never been in Ewaso Village at the time of someone's passing, so my knowledge is limited to the insights Paul shared that night, and to questions I've asked other Maasai friends since that night. They're the same questions I'd ask anywhere on Earth. When someone dies, what do you do with the body? How is it prepared? Is there a visitation? Is there a ceremony led by a priestly type—a mystic, an elder, shaman, imam, or rabbi? How much time passes before the funeral occurs? Does the corpse sit with the family and, if so, for how long?

Animist traditions have a beauty about both life and death that, to me, is unsurpassed. Many indigenous traditions vary widely based on the seasons, the rain, the sun, the wind, and the landscape that surrounds each culture—animals, plants, heat, humidity, water, desert, mountains, rivers, sand. For the Maasai in Laikipia County, the loss of a loved one or a dear friend is as sad as it is anywhere else. The void does not refill. Grief, loss, and the empty space at a table or under the sitting tree are simply a universal part of the human condition. Though Catholics attempted to convert them to Christianity for years, most Maasai have retained their own traditions, and many have created a belief system that integrates the mythology of both Catholicism and traditional Maasai beliefs. The fusion is easily witnessed in many parts of the world, including Haiti, Peru, Mexico, and the American southwest. While it is not uncommon for a dead Maasai to be ritualized by a local Catholic priest and buried with a stone marker, it is also not uncommon for the body of a dead Maasai to be bundled in cowhide and left to decompose or be eaten by predators in the bush. My Maasai friends remain devoted to their long-held traditions, and the poem Water, Earth, Sky is my attempt to show the beauty of those traditions from the point of view of a young girl experiencing death for the first time.

NOTE: The Maa name Lolkerra means "one who possesses a great number of sheep and, by extension, one who has a large flock is often very respected in the community." Nkasiogi is a female name that refers to someone who is "always in a hurry." A boma is the fencing enclosure around a nomadic community that helps to keep livestock inside at night and predators out. The Orinka is a Maasai weapon that is similar to a baton in size. Warriors are said to be able to use the orinka by throwing it accurately at a predator from up to 100 meters away. Ewaso Ngiro is the name of the river that runs near the village.

Water, Earth, Sky

Part One – Water

At dawn, three girls walk
barefoot in cool sand
on the crumbling river bank.
Fish eagle chirps, light bounces
from orange belly of kingfisher,
baboons scavenge,
and flowering violets open
like a crown honoring
the rising sun.

Nkasiogi wiggles her toes
as the soft earth kneads
her calloused, worried soul.
There is math in her head:
thirty-six hundred days
with the burden of water.

When is a girl's first time? she wonders.
Is it always at seven, or maybe eight?
Nkasiogi laughs to herself.
Her cousin has told her
of the pain
and blood
and smell
of first sex,
but Nkasiogi is in this moment
mindful of the warming morning
and counting the days and days
of hauling yellow jugs
with red plugs

that began when she was too low
to the ground for arms extended.
Now, at fourteen, Nkasiogi lifts
with biceps strong and long,
and height above her brothers.
Ankle deep in Ewaso Ngiro,
her feet crinkle and squish,
and toes, smooth like worms,
find their way through loose mud.
In the eddy, water bugs zip on
the surface, free from the
competition of current.
Does the river move slower
at dawn? she wonders.
Nkasiogi pokes a thin stick
at the water hole.
"It is deeper than before!" she says.
But her friends are climbing
the tangles of acacia limbs,
their yellow jugs empty
against the gray trunk
where the camp dog digs
in search of a smelly spiny mouse.

Across the river,
three sheep stand at shoreline,
drinking, tongues clicking,
with short bursts of breath
sucking water inward
again and again
with a hint of desperation
as if remembering
the time of no water.

Suddenly, as if waiting
for an audience,
a vulture swoops, lands,
struts, inspects and pecks
the carcass of a sheep,
the midnight prey
of a hungry hyena
left meatless
for all but birds.
Nkasiogi gasps as fear
breathes its way in
and stomach sinks
to her anchored feet,
stuck in river muck.
Her body twists to
girlfriends on tree limbs,
and digging dog, unaware.

The normal morning is gone.
Where is Lolkerra –
herder, elder, healer?
Where is Lolkerra –
father of Isina, Simu, Simon?
Where is Lolkerra –
widower, neighbor, friend?

As sunlight clears
the low clouds circling Kirinyaga,
Nkasiogi, the eldest, searches.
Cows, camels, sheep,
and goats roam untended.
And near the boma gate
Lolkerra sits, back against post,
thin legs crossed, machete tucked,
orinka in right hand,
with tire rubber sandals
twisted sideways
just enough for sleep
or death.

Water, Earth, Sky

Part Two – Earth

In death, Lolkerra's bent body
curls again like a fetus
in his mama's belly.
At the clinic entrance,
it lies on cold stone,
waiting for transport.
Day patients step around
and over the corpse
waiting their turn for the nurse.
A child pokes a cheek,
and fearless infants probe
crawl and converse
with the stiff shell
of Lolkerra
in a language of silence
long forgotten by parents,
teachers, nurses, elders.

Across the yard,
village men clean cowhide
and rehearse prayers
for the ritual of death.
When does the soul leave the body?
Nkasiogi wonders.
The waiting bench is hers alone,
a strange reward for discovery.
Waiting is new for Nkasiogi.
Her days move with water,
gardens, building boma, tending cows,

but now, waiting is waiting,
and the punishing pulse of fear
finds its way in again,
with the face of her father.
Will he be home tonight?
Will mother smile?
Will sister brew chai and brothers play
in soft sand near thorny boma?

As midday sun peaks
and shadows disappear,
Nkasiogi watches
Isima and Simu sit on soil
near their father's body.
Simon – now the elder –
places Lolkerra's
hardened hands
in his own.
All of twenty, the herd is his.

Maiyo arrives with his Bronco –
the hearse – and four young warriors
lift the body. Savannah sun
has sucked it dry as corn stalk,
hard as rock, with mouth frozen
and eyes locked.
Beyond the circle of family,
Nkasiogi stares at Lolkerra.
So new to death,
hopeful but uncertain,
she whispers to her own
silent power –
soon spirit will dance, she says,
soon spirit will soar

Water, Earth, Sky

Part Three – Sky

Through plastic, sticks,
and mud of elder house,
Nkasiogi watches
through a crooked doorway.
Lolkerra lies
stretched and straight
on cuts of cowhide
as warriors sit in silence
with space enough for kneeling.

Nkasiogi counts her days
by the moon,
and as a crescent
rises in the east,
she imagines Lolkerra young again,
laughing with Simon,
bouncing Simu on strong shoulders,
and hand in hand with daughter Isima
as they watch the grazing herd
near river's edge.
Today is for remembering, she thinks,
today is for awareness
of precious time.

As firelight takes the place of setting sun,
the reluctant witness watches
through tiny cracks of elder shelter
as cousins, brothers, and sons,
smear sheep fat on the naked body.

Wounds of the living
need places and people
to feel and heal,
but sheep fat is for soothing
the soul of the dead,
an offering to ancestors,
a ritual for remembrance.

Tears flow from Simon's eyes
as he pours his father's mouth
full with thick fat of sheep,
full until throat is silent
but for the sound of spirits.

Cowhide is stretched
and body wrapped and tied
like a tight brown cocoon.
Strengthened by sorrow
a bold warrior
carries body to bush,
beyond rocks and river,
deep beyond deep
until no one,
not even Nkasiogi,
can find the shepherd
whose body waits for birds.

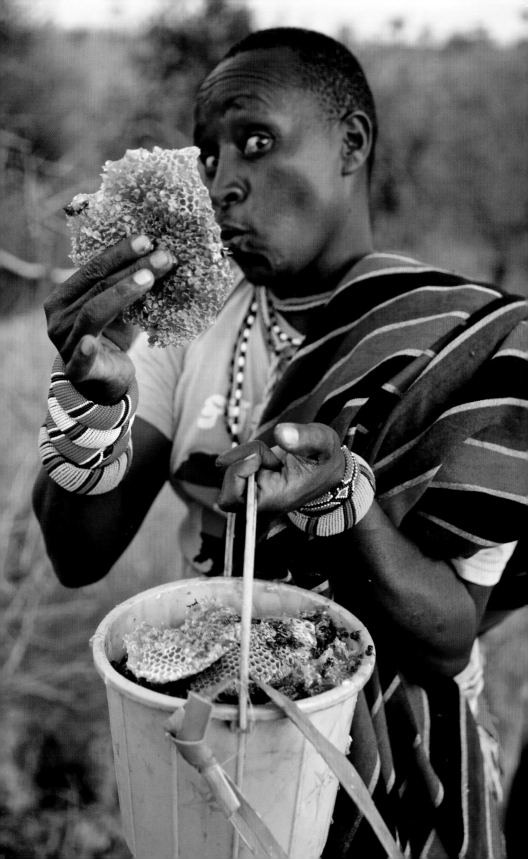

KANDARI, THE BEEKEEPER

Where would the world be without honey? I'd never asked nor imagined this question until a lull on a drive across the Laikipia countryside. I'd been on several safari drives in Kenya and Tanzania before I finally asked about the large, cylindrical tubes that hang horizontally in trees throughout the bush. In the Loisaba and Mpala conservancies, it's nearly impossible to find a tree that doesn't have them hanging on sturdy twine from the upper branches. They are just one example of what some call "nature-based enterprise," or what Winnie The Pooh calls "honeypots." Many farmers and herders in Laikipia County own as many as ten to twenty beehives, and they harvest honey regularly. Each hive can produce up to 20 kilograms of honey several times a year. Honey sells for as much as 250 to 1000 Kenya schillings per kilogram. According to Paul Lebeneiyo, "the price depends on the season of flowers."

Kandari Parsulan is a nomadic herder I've known for many years. Charismatic, well-educated and funny, Kandari and I make time to see each other during each visit I make to Ewaso Village. His home changes regularly, but his livelihood remains the same because Kandari moves his family and community often to ensure that his livestock have adequate food and water. And, no matter the new landscape, Kandari finds nearby trees for his honeypots. During a 2019 visit to Laikipia County, Kandari and his family invited our group to help harvest honey before their big community move the next day. With several of us watching from solid ground, Kandari's young cousin climbed barefoot to the highest part of the tree while holding a smoldering stick in his left hand. Once he approached the hive, he blew on the red embers until a flame erupted, then he blew it out quickly and pushed the smoldering end of the stick into the circular opening of the hive. He puffed hard against the opening to contain the smoke inside the tube, and within seconds we could see a stream of bees moving quickly out the opening in the other end of the hive. Then, with some bees still hovering and a few stinging his bare arms, he reached inside and scooped handful after handful of honey and honeycomb into a blue plastic bucket that hung off his left forearm. Once he was back on the ground—and with smiles all around—each of us dabbed our fingers into the bucket and scooped spoon-sized portions of raw honey into our mouths.

"African lollipops!" said Kandari. "There is nothing better in the bush."

The season of flowers was a good one.

NOTE: The Maa word for beehive is "inkidong." A tree is called "ichani."

Kandari, The Beekeeper

There's Kandari at twilight,
in search of honey
whimsical, fearless,
free climbing ichani
with calloused feet
and bare arms punctured
by bees and scrapes
of acacia needles.

Held tight in right hand,
two smoldering sticks,
and like a busy yogi,
he pushes deep breaths
through circled lips
across embers,
filling chambers
of inkidong
with gusts
of blue smoke.

In seconds, a low buzz,
as clusters of bees
stretch across the canopy
consuming the silence.
Like a gymnast balanced
on beams and branches,
Kandari the beekeeper –
stung and strong and satisfied –
combs his hands through
dense, dripping amber.

"African lollipops!"
he shouts to us
from thirty feet up,
as he digs a dollop
and sucks from sweet
sticky fingers.

From below, we watch
his brown body,
a sinewy silhouette
against sunset,
shifting, stretching,
bending, balancing
as scared bees
hover, recover
and attack back,
biceps, cheeks, ankles, wrists.

Kandari is immune to stings
since brothers and sisters and cousins
climbed together to harvest honey,
each on a daily quest for lollipops,
each bringing joy and laughter
to the tree tops.

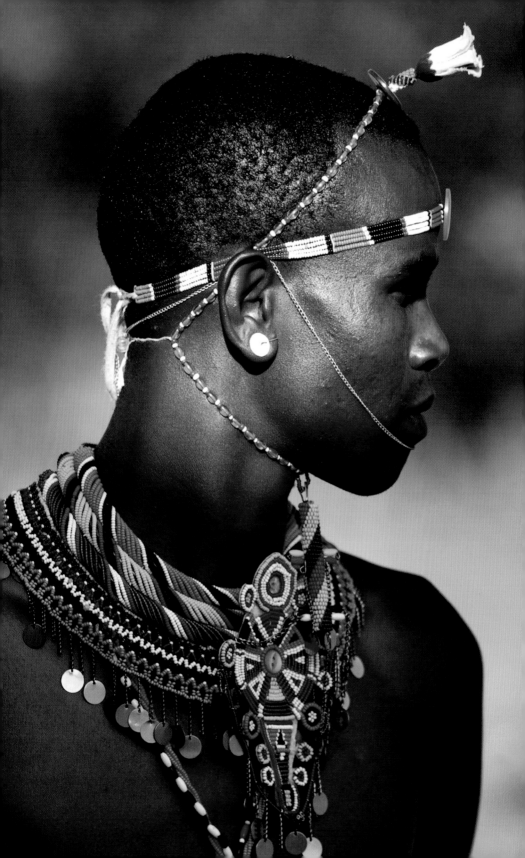

AFTERWORD

After eighteen months, two jabs, three nasal swabs, and four flights, I finally made it back to Ewaso Village. My September 2021 visit was brief and filled with precautions, but profound in its outcome.

From the air, the savannah was like an old uniform with folds and creases and worn pockets, so pale and brown that the gravel runway was barely distinguishable from the wilted bush. Another drought. The only color I could see near the runway was my friend Modesta's bright green shúkà, the Maa word that best describes the dress-like robe that covers women's bodies. On previous arrivals, a smiling warrior would gesture me toward a Land Cruiser readied for a game drive. But the global pandemic had impacted this community as much as any on Earth, and it was my friend Modesta who arrived to transport me to the village. She was like a signal standing alone as she waved a timid hand to greet me.

By September, 2021, very few cases of Covid-19 had been reported in Laikipia County with even fewer in the rural areas outside of Nanyuki. Since most locals rarely travel beyond a twenty-mile radius, that was not a surprise. Covid testing was rare in Laikipia County, and the shelves of the two-room medical clinic in Ewaso Village were bare.

Clinic Shelves – 2021

Modesta and I were both wearing masks when we greeted each other by touching elbows. "I've been vaccinated," I told her. "Me too," she said, "but not our driver. It's good to be careful."

I'd arranged to stay at Paul Lebeneiyo's Lewaso Lodge. But with no tourists coming to Kenya, I was the first guest in nearly eighteen months. Like so many men in the village, Paul had taken work at a nearby conservancy. "He'll be able to join you shortly," said Modesta, "maybe in an hour or two." "And Kandari?" I asked. "What about Kandari?"

Even Kandari had gone to Nairobi to find work. I'd only known him in the village or at his boma, so the idea of Kandari in Nairobi was foreign to me. I couldn't imagine the challenges his family faced without his energy, strength, and experience.

Without stops to photograph wildlife, the drive to Ewaso Village on a dirt track across Loisaba Conservancy takes about forty minutes. The route appears flat from above, but in the old Bronco, the bumps and dips made it feel like an amusement ride. Our small talk included the drought, a condition that by now had become so regular it was normal. "There is no rain for many months," said Modesta. "And conflict between the herders and the conservancies is ugly again. Even worse than before." The battle lines had been drawn by British mapmakers more than a century ago when what was once grazing land for pastoralists became off limits through a system of title deeds. In a practical sense, the pastoralists have no grazing rights unless granted by the ranchers or conservancies. The fight is, in some ways, like the fight at the southern border of the United States, and it tests the idea of what is better: walls or bridges? Who gets to say where the line is drawn and why? "Some herders are armed now with guns," she said. "It is a difficult time." But "difficult" was an understatement. It's an ongoing crisis, and for the social justice crowd who also happen to be conservationists, there's little clarity about what's right.

There's an old adage that says "if something is done wrong in the beginning, it's often done wrong in the ending." It's true when we watch a bad movie or read a bad book. It was true when NATO forces invaded Afghanistan and then botched their departure two decades later. It was true when the United States and China blew their responses to the pandemic as early as January, 2020. And it was true when the colonial powers in Kenya pushed the Maasai and Samburu herders onto arid patches of land they knew would be less productive. But many colonialists didn't care and, over time, the mistakes made in the beginning simply became worse.

Of course it was a difficult time, I thought. Drought, pandemic, no tourists to build the economy and, like most countries, a government with too much corruption, a shaky tax base, and so few resources that there was little choice but to turn its back on rural communities. Resources for a public school and a tiny medical clinic in a place like Ewaso Village were hard to come by.

As we drove, it occurred to me that I'd never had a personal conversation with Modesta. When at the lodge, we were usually part of a larger group engaged in small talk and hospitality. This would be different, I thought, perhaps a chance to get to know her better. At the time, I had no idea how significant our journey would become.

Every arrival at the modest Lewaso Cottages lodge is one to remember. As soon as visitors exit their vehicle, the warmth and joy of the Maasai is shared with each visitor through song and dance. Since I was traveling alone, I'd imagined nothing more than parking and walking into the open-air lodge. But, as the 4x4 turned from the indistinguishable bush into five acres of random, semi-fashioned greenery, I could hear the voices of Chui Mamas. About thirty women had congregated to greet me and, for a moment, Shakespeare popped into my head—surely this was "much ado about nothing." My inclination is to be bashful or hide behind my cameras, but I took a breath and became mindful of the attention. This VIP treatment was, it seemed, about filling a desire for normalcy that we all shared. Singing and dancing together gave hope to a community that had very little to celebrate since the global lockdown began during March 2020.

The physical attributes of the lodge hadn't changed. A beautifully hand-carved table and hardwood chairs still filled the center of the open-air room. The comfort of worn, overstuffed couches in the sitting area still looked inviting. And the view of the savannah still gave me the haunting, conflicted feeling that can seem dull, mysterious, and intimidating all at once. What was out there is still out there, I thought. I couldn't really see it before, and I can't really see it now. Yet when we set aside our fear, we open the door to our imagination. We see what we see. And there it was for me to take in as if it was the first visit: centuries of struggle, centuries of life and death, centuries of song, dance, family, and joy, centuries of herding and roaming in search of food, water, and shelter.

The lonely energy of the lodge hit me hardest. What had always been joyful was now dim, spiritless. The empty space had the weight of an emotional burden, something to be maintained with nothing more than hope and dreams. The lodge is a place for people to convene. It's a place for laughter and stories, drinking Tuskers beer, and breaking bread. But that energy had faded with month after month of a sickening virus that destroyed both life and livelihood

for millions of people around the world. Ewaso Village was no exception; rather, it was a poster child for the devastation caused by a pandemic that's left millions of people dead, and millions more ignored, forgotten, and desperate.

Over rice, noodles, bread, and sliced hot dogs in a broth, Modesta and I took the slow, tenuous steps of tango dancers calculating the next move. I have more than a decade of shared experiences with Paul and his team, but most of our adventures, lightness, and laughter have been with male guides. With Modesta, there was unease at first, fits and starts, and uncertainty. Tending to my arrival was awkward, and probably not her first choice, but there had been no one else to greet me at the plane. We soon discovered that while both of us were shy, survival in our professions required putting it aside. Where both of us prefer privacy, our careers made privacy a thing of the past. Where both of us had once thought no one would really care about our ideas or thoughts, survival had made us both aware that our thoughts and ideas mattered. Neither of us needed to control the discussion, we needed to trust our energy and our intuition. We needed to listen and to share. Perhaps best of all, Modesta figured out quickly that the trappings of masculinity, patriarchy, and machismo were not part of my wheelhouse. We would find our way.

As we were having our modest lunch, Paul called with an update. He'd left work to join me only to be diverted by the emergency of a young woman from the village in need of a cesarean section. The drive to the hospital in Nanyuki takes as long as six hours, but it had become routine. Paul has a terrific giggle, and I could hear him on the tiny speaker when he welcomed me as his brother. And brothers, he said, understand. It's life in the village.

Tea. Coffee. Biscuits. The hot, sleepy quiet of midday in the savannah. As much as I'd learned about the Maasai and Samburu, there is always so much more, especially in the lives of women. Just as colonial powers had subjected herders to their rules, the Maasai and Samburu cultures that had long been dominated by men had subjected women to their rules. The opportunity was now ours, and Modesta welcomed the awkward questions I'd trained for years to ask. There was grace in our focus and intention.

A person's name tells a story, and the meaning often reveals great insights. The name Modesta originated in Latin and means "modest"—which is certainly fitting. But she also uses the name Ellie (short for Eleanor) which

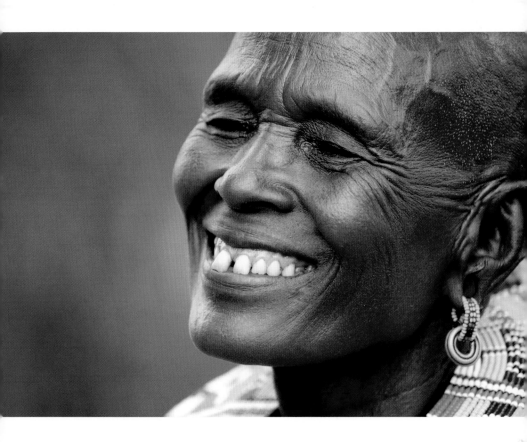

in Greek means "shining light." Her favorite name, she said, is the one given to her by her Samburu mother. She was born Ntito Enkang, which means "daughter of the home." Her mother named her Ntito Enkang because she'd given birth near their homestead while she was out collecting wood for the cookstove.

Like so many Maasai and Samburu girls who are promised at a young age, Modesta had been pushed into an arranged marriage by age fourteen to a man she had never met. By the time she was eighteen, she had two beautiful daughters, Naserian and Naseiku. When the eldest was three, the man Modesta was forced to call "husband" left in the middle of the night. He headed for Nairobi and was never heard from again. As a single mother with no education and no job in a country that has no social services in rural areas, Modesta had no options. Years later, her experiences would guide the Chui Mamas in a quest for education, sustainability, and independence. At the time, the local Catholic church was the only place where she could find

community and assistance. There was a churchyard for her two infant children to toddle and roam freely, and space for her to think, plan, and grieve.

Early in a journey that can only be described as terrifying, the local priest—a middle aged man from somewhere in Europe—spotted Modesta sitting near a tree with tears running down her face. He asked her why she was crying. Her story came out with each teardrop. Modesta doesn't remember how long it took for her share her story, but when the priest heard it, he did what all of us wish priests would do. He helped her and her young family find shelter and a path to education and a better life. Modesta's journey to become a founder of the Chui Mamas took years, but she refused to give up.

Now, years later, here we were. Our walls dropped into bridges. We were two people eager to learn from each other.

"What about circumcision?" I asked. "Do you mind if..."

"Yes, most Maa girls are circumcised," she said. "Samburu too."

"Against their will?" I didn't mean it to sound like a dumb question. Of course it was against their will. As I mentioned earlier, most Maasai and Samburu girls are circumcised before puberty. But circumcision was also part of the culture and a practice that goes back centuries. All around the world, rites of passage have a legacy of their own and while some may be harmful, they can also be difficult to ignore or bring to an end.

Modesta confirmed that boys and girls are circumcised without any painkiller. Showing pain by screaming out or fainting is frowned upon. The discomfort is excruciating, she said. For girls, the long-term medical consequences can be considerable, especially regarding reproduction. While I hadn't considered that Modesta might be a vocal opponent of female circumcision, she was. It was part of the patriarchy in a culture that has reinforced the power of men through their control of women. Yes, patriarchy is an old story on many parts of the planet, but it's particularly egregious when girls are circumcised before they're capable of understanding the consequences and then forced into marriage to an older man they've often never met.

Modesta believes it's an issue best resolved by women in the community. Education is part of the change. The Chui Mamas are part of the change. Midwives are part of the change. No one likes having ideas or policies dictated

to them. Building consensus matters, and being preached to by the West is perceived by many of the local women as noise.

According to Modesta, the strength of the Chui Mamas has grown during the pandemic. With no work, no government support, and often no husband or family to rely upon for sustenance, the women are gaining strength in numbers and the wisdom and experience of the collective. They've expanded their beading work to include designs that are more universal and easier to export, not just those representing tribal history or customs. They've taken shifts sewing masks for local people to use to ward off the virus. To fight the drought, many have begun their own organic gardens. Many are keeping bees. Some are learning bookkeeping, and some have opened bank accounts.

"I have always wanted to garden," said Modesta. "And the pandemic gave us time to do that. With no guests and time on their hands, the caretakers of Lewaso Lodge have planted more than an acre with lettuces, beet root, corn, tomato, and spices." Modesta has taught her daughters to cook a variety of meals, not just those indigenous to the Maasai and Samburu. Because there is a well at the lodge, they have water for irrigation and enough leftover for the Chui Mamas version of a greenhouse. Farming is not traditional for the Maasai, but with herding issues and drought, traditional lifestyles are changing.

"This is another way for women and families to be independent," she said. "And tourists will like it, too."

After several decades of travel as part of my work, I've seen and experienced many things that add to both the complexity and simplicity of the human experience. Governments fight over power and resources. Some fight to achieve equality, but few recognize that we are all more similar than we are different. Most people want a good healthy meal, opportunity for their children, clean water, and a roof over their heads. So far, I've not found a single nation or tribe that has everything figured out. Most countries, cultures, families, and individuals are a work-in-progress. When Modesta asked me similar questions about my own upbringing in the Midwestern part of the United States, I told her that my youth was as predictable and mundane as a loaf of white bread. We laughed and laughed.

"It wasn't possible to imagine this when I was sitting in Mrs. Gettsinger's first-grade class," I said. It was true. The primary school I attended during the early 1960s was in Council Bluffs, Iowa—about as far from Ewaso Village as one could get. "Yet when I walk into a first-grade class at Ewaso Primary, it feels normal to me. Some kids have beat-up clothes, some wear a clean uniform, some pull on a girl's hair, some stare out the window daydreaming, some trip their classmate as he walks toward the blackboard to answer a math problem. It's just life," I said, "it's just life."

"And you?" asked Modesta. "Were you …"

"Circumcised at birth," I said, "I didn't have a choice either."

"Did it hurt?"

"You betcha," I smiled. "Well, maybe not at the time, but the memory of that snip snip might explain my occasional limp." We laughed again. Men and women often struggle to find their way into conversations like ours. But Modesta and I proved what I have long believed—it's possible. Maybe not on a first visit, maybe not when surrounded by family or a group, but it's possible. During a long afternoon of uninterrupted conversation, we'd had no agenda, and there was nowhere we needed to be. I wasn't a typical guest. I'd participated in rituals, photographed wildlife, and visited the school, clinic and community on many previous trips. I'd brought groups of friends to enjoy their insights, skills, and talents through the joys of the savannah. Whatever obligation Modesta may have felt to entertain me or provide the comforts extended to a guest had gone out the window by the time we'd finished lunch. On this afternoon, we were where we were supposed to be.

Near the equator, sunset always happens around the same time. About 6:30 p.m. As the sun finally dropped below the horizon, Paul arrived. We picked up where we'd left off two years earlier with a warm hug and my delight at yet another giggle. My hair was shorter. His waist was smaller. We'd both lived through eighteen months of chaos.

"What about Travis?" he asked. "Bendis? Hernando? Tina? Barbara? Karen? Bill? Nigel? Sharon? Bob? Vivien? Diane? Devon?" Like good guides everywhere, Paul's Rolodex was in his head. He remembered everyone who'd joined me on the groups I'd brought to Ewaso Village. "What about LCCF?" he asked. The small not-for-profit organization based in New York

First Grade – Council Bluffs, Iowa – 1962

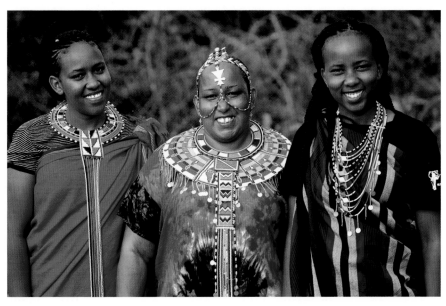

left to right: Naseiku, Modesta, Naserian – 2001

had provided support for the school and clinic for nearly twenty years. "Dr. Paulie?" he asked. "Sue? Jim?" Paul smiled with every name in question. These were his people as much as he was theirs.

With the help of USA FOR AFRICA and several private donors, the Loisaba Community Conservation Foundation (a.k.a. LCCF) had worked with the Kenya Red Cross to distribute more than 20 tons of food to Laikipia County during late 2020. During the second quarter of 2021, a fund had been established to provide additional meals through Ewaso Primary school until the economy rebounded.

I have no interest in the local politics of the Maasai or Samburu, but gossip about the community and updates on my guide friends carried us through dinner. He repeated what Modesta had told me. "There is no work here," he said, "and it's difficult to move our herds to market." Robin? Sunflower? George? Juma? The pandemic had left most of the warriors desperate to overcome a disease they hadn't imagined. Our conversation that night was a mix of laughter, fond memories, and reflections on the sadness of a global pandemic.

Then, shortly before sleep, a remarkable thing happened. For the first time in more than a dozen visits to Ewaso Village, it rained! And it was a good rain, soft but steady for more than an hour. I'd never heard rain fall on the grass roof before. It was pleasant, and the beat was steady yet unremarkable. Not every guest would have enjoyed the drips and dribbles inside the lodge, but we laughed together as the steady rain helped us find leaks in a roof that had been untended for months.

The rain wasn't enough to turn the bush green or fill the ponds for hippos. Still, when we visited the garden the next morning, there were puddles around the lodge and mud deep enough to hold our footprints. The corn was knee high. The zucchini were as big as my arm. And the lettuce was rich, full, green and ripe.

We made a quick stop to see progress on the new community well, then dropped by the clinic to resupply first aid. What I'd been able to carry on the small plane into Laikipia County wouldn't last the clinic for long, but it was a start of a good day in Ewaso Village.

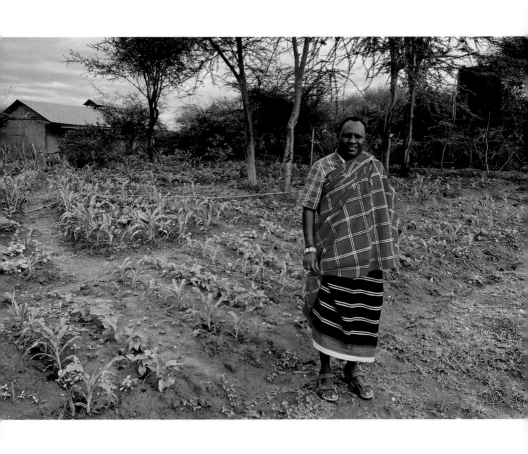

A lifelong Midwesterner and native of western Iowa, Chip Duncan has produced more than fifty nonfiction films for international broadcast and distribution. His work as a photographer and filmmaker has taken him to ice fields, war zones, slums, shipyards, museums, palaces, vineyards, beaches, deserts, rainforests, savannahs, and farmlands. He counts Peru, Ethiopia, Afghanistan, and rural Kenya among his favorite places. Duncan's previous books include the short story collection *Half a Reason to Die* (SelectBooks, NYC, 2017), photographic collections *Inspiring Change* (Thunder House Press, Milwaukee, 2019) and *Enough to Go Around* (SelectBooks, NYC, 2009). Duncan also speaks publicly on the impact of climate change as part of *The Three Tenors of Climate Change*.

Ewaso Village is Duncan's first book containing his poetry and the first in a trilogy featuring indigenous cultures from around the world.